D0768855

DISCARDED
Western Wyoming Community College

Franz Marc
Postcards to Prince Jussuf

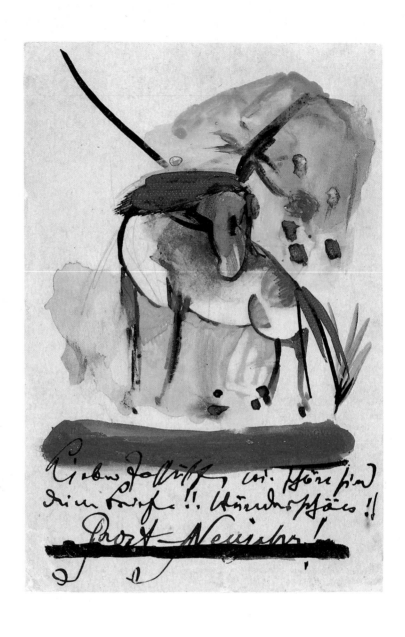

Peter-Klaus Schuster

Franz Marc

Postcards
to
Prince Jussuf

Prestel

This book is an abridged version of the
German edition, *Franz Marc, Else Lasker-Schüler:*
"Der Blaue Reiter präsentiert Eurer Hoheit sein blaues Pferd" - Karten und Briefe,
published by Prestel in conjunction with the exhibition of the same name
held at the Staatsgalerie Moderner Kunst, Munich,
from November 20, 1987, to February 28, 1988

© 1988 by Prestel-Verlag, Munich
© of quotations from, and illustrations by,
Else Lasker-Schüler by Kösel-Verlag, Munich

Cover
Prince Jussuf's Lemon Horse and Fiery Ox
Postcard of March 9, 1913
(plate 9)

Frontispiece
Horse
Postcard of December 30, 1913
(plate 26)

Translated from the German by David Britt

Prestel-Verlag
Mandlstrasse 26, D-8000 Munich 40
Federal Republic of Germany

Distributed in the USA and Canada by
te Neues Publishing Company, 15 East 76 Street,
New York, NY 10021, USA
Distributed in the United Kingdom, Ireland
and the rest of the world with the exception of
continental Europe, USA, Canada and Japan by
Thames and Hudson Limited,
30–34 Bloomsbury Street, London WC1B 3QP

Printed in the Federal Republic of Germany
Offset lithography: Karl Dörfel, Munich
Composition: Typoservice Urban, Munich
Typeface: Weiss Antiqua of Berthold AG, Berlin
Printing: Pera-Druck, Gräfelfing near Munich
Binding: Conzella, Urban Meister, Munich
ISBN 3-7913-0883-1

Contents

Franz Marc and Else Lasker-Schüler:
A Harmony of Contrasts

7

Biographies

30

Postcards to Prince Jussuf

33

List of Plates

91

Bibliography

103

Franz Marc and Else Lasker-Schüler
A Harmony of Contrasts

Confusions

A painter meets a woman poet whose personality differs from his own almost to the point of contradiction, and yet he calls her "sister" – that, in a nutshell, is the story of the friendship between Franz Marc and Else Lasker-Schüler.

The vastness of the gulf between them is apparent even in photographs. Franz Marc (fig. 1), walking with his wife Maria and dog Russi in the meadows near his home at Sindelsdorf in Upper Bavaria, presents a placid, middle-class image that makes a weird contrast with the artifice of Else Lasker-Schüler in her self-invented role of Prince Jussuf (fig. 2). The encounter between these two individuals is not so much an encounter between painting and poetry as a contrast between solid respectability and eccentric bohemianism, between rural contentment and the exotic pleasures of the city, and – in terms of German artistic life before World War I – between the countrified Bavarian royal capital of Munich and the frenetic metropolis of Berlin.

According to Maria Marc, Lasker-Schüler and Marc first set eyes on each other in December 1912, in the Café Josty in Berlin; it was a

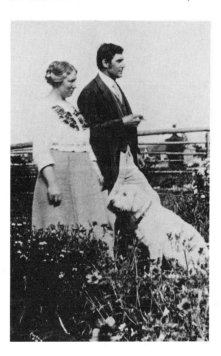

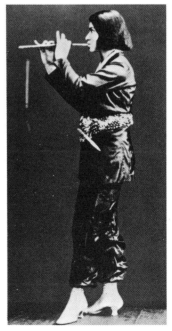

Fig. 1 Franz and Maria Marc. Sindelsdorf, 1911

Fig. 2 Else Lasker-Schüler as Prince Jussuf of Thebes. 1909 or 1910

7

situation that placed them physically at close quarters, but mentally very much at arm's length.[1] Franz and Maria Marc were sitting at one table, with the art dealer Herwarth Walden and his young wife, Nell; and Lasker-Schüler, who had recently been divorced from Walden, was sitting at another table.

The Marcs were fairly used to this sort of social complication: this was not their first visit to Berlin together, and they were spending it partly at a family Christmas gathering in the house of Maria's parents and partly – as on their previous visit, early in 1912 – on renewing their acquaintance with the Berlin art world. In the expectation of meeting Lasker-Schüler, Marc had sent her the drawing *The Blue Rider with His Horse* (plate 1) as a greeting, probably on the day before he left Munich. Her delighted reply reached him in Berlin the very next day. According to Maria Marc, she reacted rather ill-humoredly;[2] but this cannot be so. Lasker-Schüler writes as to a close friend, expressing her joy at the form of Marc's greeting to her, a self-portrait with a towering horse.

This first painted greeting shows Marc adopting the name "Blue Rider," carrying on the game that Lasker-Schüler had begun in an earlier letter, and which she maintained throughout her correspondence with him. To Lasker-Schüler, the Blue Rider (*Der Blaue Reiter*) was not a Munich art group but one man, Franz Marc.

Her intimate tone, even in the reply to this first greeting from him, need not come as a surprise. The painter and the poet already knew each other, if not personally, at least through their work. In September 1912, Marc had published a woodcut illustration to Lasker-Schüler's poem "Versöhnung" (Reconciliation) in Walden's magazine *Der Sturm* (figs. 3, 4). On November 9, she wrote to Marc at Sindelsdorf, introducing herself as Prince Jussuf of Thebes, author of many poems, including "Versöhnung." "Why," she wrote, "did you do the drawing of Reconciliation? Are you as painfully bereft as I am, with no path ahead, nothing but chasms?"[3]

She was already contemplating a visit to Marc, and sent him her two latest books. A few days later, however, Marc received a second letter in which Lasker-Schüler declared the first one to be a forgery. She did not, she said, subscribe to *Der Sturm*, and knew nothing of any woodcut.[4] The anguished and confused tone, especially in relation to *Der Sturm*, could only be a consequence of the divorce from Walden, which became final at around this time.

Marc did not let himself be troubled by this somewhat whimsical prelude to his visit to Berlin. As far as he was concerned, Walden, his Sturm gallery, and his journalistic activities were the most reliable outpost of the modern movement in general, and of *Der Blaue Reiter* in particular, in Berlin. "Walden still impresses me; he lives and works for

Fig. 3 Franz Marc. *Reconciliation.* 1910. Woodcut illustration for Else Lasker-Schüler's poem "Versöhnung." *Der Sturm,* September 1912

Fig. 4 Else Lasker-Schüler "Versöhnung." *Der Sturm,* September 1912

"Reconciliation:
A great star will fall into my lap...

Let us watch tonight,

Pray in those tongues
That might be carved on harps,

Let us be reconciled to-night –

So much godshine over-flows.

Our hearts are children,
They want tired sweet rest.

And our lips want to kiss,
Why draw back?

Is my heart not next to yours –
Your blood still colors my cheeks red.

Let us be reconciled to-night,
If we embrace, we shall not die.

A great star will fall into my lap."

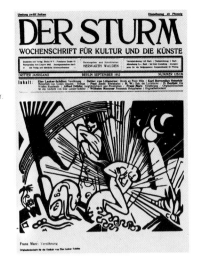

DER STURM
WOCHENSCHRIFT FÜR KULTUR UND DIE KÜNSTE

Franz Marc: Versöhnung

Versöhnung

Es wird ein großer Stern in meinen Schoß fallen . .
Wir wollen wachen die Nacht,

In den Sprachen beten
Die wie Harfen eingeschnitten sind.

Wir wollen uns versöhnen die Nacht —
So viel Gott strömt über.

Kinder sind unsere Herzen,
Die möchten ruhen müdesüß.

Und unsere Lippen wollen sich küssen,
Was zagst du?

Grenzt nicht mein Herz an deins —
Immer färbt dein Blut meine Wangen rot.

Wir wollen uns versöhnen die Nacht,
Wenn wir uns herzen, sterben wir nicht.

Es wird ein großer Stern in meinen Schoß fallen.

Else Lasker-Schüler

the matter in hand, with an ambition that never does him discredit," Marc wrote to Wassily Kandinsky from Berlin.[5]

However, this alliance with Walden, which was to culminate in the *Erster Deutscher Herbstsalon* (First German Fall Salon) of 1913, never affected Marc's love and respect for Lasker-Schüler's work and for the poet herself. For both Franz and Maria Marc, she represented an opening into the literary world, which was totally alien to them, and which they now encountered for the first time. "We are meeting an awful lot of people," wrote Marc to Paul Klee; "this Berlin, and not least literary Berlin, is a real witch's brew, with its devils and its deities, great and small."[6] And in that witch's brew, as he wrote to Kandinsky a few days later, "we have found one magnificent person, Else Lasker-Schüler. She will probably come to Sindelsdorf for a few weeks in January, to which we look forward *enormously.* This brief statement will no doubt elicit a thousand questions from both of you. Questions that cannot be answered in a letter, because they contain whole novels within themselves."[7]

Some of these novelistic complications emerge in one of Maria Marc's delightfully informative "gossip letters" to her friend Elisabeth Macke, wife of Franz Marc's fellow *Blaue Reiter* painter August Macke, written a month or so later:

Berlin held a number of surprises for us. We were longing to meet the *Sturm* circle of writers – but the reality fell rather short of our expectations. As time went on, we got more and more depressed. We started to feel that most of them were living examples of how life in a big city can corrupt people. Almost all of them seemed corrupted. All their relationships are riddled with jealousy, envy, lies, and deceit: there's not one of them that can trust any other. The air is impure.

What made the whole thing so interesting, of course, was our having a foot in two different camps – on one side, Else Lasker-Schüler, Walden's divorced wife, and on the other, Walden himself with his present wife, who is a perfect *goose*. Lasker-Schüler (we had corresponded with her before we came to Berlin, and we thought she and Walden had parted amicably, because that was what Walden told us in a letter) is a curious person – we liked her enormously right from the start. When you know her, you immediately understand her poetry. She is out of sympathy with the people among whom she has lived – and still lives – her life. She too has been corrupted. She is now very unhappy. Since the divorce, which did not go as smoothly as Walden would have us believe, she has been short of money, and her nerves have suffered badly from the shock.

We brought her back to Sindelsdorf to recover, but she couldn't bear the loneliness and the silence in the countryside. For years she has been living in Berlin, between four walls and in and out of coffeehouses, and the sudden change did her no good at all but simply upset her suffering nerves. We took her back to Munich, where she has friends and is taking a cure that seems to be doing her more good.[8]

Subtract the affectionate sympathy from these words, and you have Lasker-Schüler as the hysteric, the denizen of the literary coffeehouses, whose overheated nervous system reacts allergically to the world of Nature. Franz Kafka, who made no secret of his dislike for her, described her in 1913 as "a high-strung metropolitan type.... I always picture her as an alcoholic, dragging herself at night from one café to the next."[9] Walter Benjamin – who, unlike Kafka, liked her poetry – was another who saw her as "vacant, sick, hysterical."[10] To her admirers, on the other hand, such as the Berlin poet and bohemian Peter Hille, she appeared as "the Black Swan of Israel, a Sappho whose world has shattered. Radiant as a child; steeped in primeval gloom. In her hair night wanders, winter snow. Her cheeks moist fruits, seared by the Spirit."[11]

These contrasting images reflect the fascination of "the greatest woman poet that Germany has ever had" (as Gottfried Benn called her), who lived the life of a middle-class dropout. She came of a prosperous Jewish family; after her divorce from her first husband, Berthold Lasker, a doctor, she took her illegitimate son and launched upon a precarious bohemian existence, living only for her poetry.

It was while she was still married to Walden, her second husband, that Lasker-Schüler adopted the alternative identity of Prince Jussuf of Thebes. Gottfried Benn has left a vivid description of her highly picturesque public appearances in the guise of this *alter ego*, as shown in her 1912 self-portrait (fig. 5):

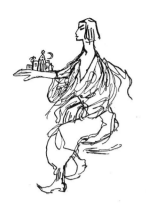

Fig. 5 Else Lasker-Schüler.
Self-Portrait. Title page of
Hebräische Balladen
(Berlin, 1913)

She was small, and in those days slim as a boy; she had jet-black hair, cropped short, which was still extremely unusual in those days, and an elusive, inscrutable look in her great mobile black eyes. Neither then nor later was it possible to walk across the street in her company without the whole world coming to a halt and looking at her: eccentrically full skirts or trousers; improbable upper garments; neck and wrists festooned with showy, fake jewelry; chains and earrings; pinchbeck rings on her fingers; and, as she was always brushing strands of hair away from her eyes, those rings – the sort a housemaid might wear – were constantly in evidence. She never ate regular meals – indeed, never ate very much at all – and often lived on nuts and fruit for weeks on end. She often slept on benches, and she was always poor, in all situations and at all times.[12]

It must have been in much the same picturesque guise that Lasker-Schüler was seen at Marc's side at Sindelsdorf and in Munich. She knew Munich well, and often went back there in later years. There, in August 1914, she was arrested in the street four times for wearing her "gala war jewelry."[13] When she visited Munich in 1916, in the middle of World War I, she took the precaution of wearing a sash in the black, white, and red colors of the German flag, as proof of patriotism. Just in case this did not work, she had provided herself with another sash in the blue and white colors of Bavaria.[14] People in Munich, who had an artists' colony of their own in the Schwabing district and were fairly used to bohemian lifestyles, were decidedly upset by Lasker-Schüler's appearance. To Marc she described them as "tactless Philistines," lacking in proper reverence for her as Emperor Jussuf Abigail.[15]

She had other things to say about Munich. Even before her visit to the Marcs, she had published an essay on the city in *Der Sturm:*

> Munich is a paradise that is never lost; Berlin is an asphalt safe-deposit.... I always want to kiss Munich, if only because I have left Berlin behind; I feel like someone who has separated from a boring *cocotte.* My friends play the accordion, and we stroll past shopwindows full of pious relics: old master paintings, devotional jewelry, wild weapons from the tombs of biblical potentates, and everywhere the blue eyes of King Ludwig! Munich is a gigantic chest of drawers, carved out of a bone from a Bavarian Alp. One can so piously putter in Munich, and recline in comfort on well-upholstered memories. Here it feels good to be one's self.[16]

For Lasker-Schüler, the pleasures of Munich included the Café Bauer and the artists' bar, Simpl. Her publisher, Heinrich F. S. Bachmair, lived in Munich, and the poet Karl Wolfskehl was another longstanding acquaintance. Now she met her Blue Rider's friends: Heinrich

Campendonk in Sindelsdorf, and later Baroness Marianne Werefkin, Alexei Jawlensky, and probably Klee.[17] Marc also introduced her to Kandinsky and his companion, Gabriele Münter.

This encounter, which probably took place in Kandinsky's apartment in Schwabing, was a fairly cool one, according to Maria Marc: "Lasker-Schüler strenuously resisted Kandinsky's art. She always said 'professor,' not 'artist.' The paintings on glass, the images of saints, got on her nerves, and as Kandinsky doesn't know her very well he has gotten it into his head that she is some kind of a 'Weltschmerz specialist' from the Café des Westens in Berlin."[18]

Lasker-Schüler did not leave matters there, however. A few days later, at Marc's exhibition in the Galerie Thannhauser, she publicly insulted Gabriele Münter. Another letter from Maria Marc to Elisabeth Macke gives the details of this distressing scene:

> So there we were sitting in Thannhauser's gallery, Münter and I, when in came Lasker-Schüler. She greeted us very warmly and we all went round [the exhibition] together. Then Lasker-Schüler said in a rather emotional way, "This painting moves me very profoundly."
> Münter asked, "Which one? The tiger or the monkey?"
> Lasker-Schüler: "The tiger."
> Münter: "What is it about the picture that moves you?"
> Lasker-Schüler: "It's so dangerous."
> So we separated, quite amicably, and went to look at other paintings, etc. Suddenly Lasker-Schüler comes striding up to Münter and starts off: "What makes you want to insult me in this way? I am an artist through and through…I am strong, a really strong person, and I won't take that from such a total *nonentity!*"[19]

This scene, which Lasker-Schüler herself regarded as an act of friendship, in defense of Marc, lost her none of his goodwill. In a postscript to the same letter, he suggested her as a tonic for August Macke: "If August starts putting on weight again and getting complacent, I prescribe fourteen days with Frau Lasker-Schüler – that'll help! But she's magnificent, in spite of all the dumb things she does."[20]

The "Wondrous" Postcards

From the very outset, in spite of all the upsets and amazements that attended their friendship with Lasker-Schüler, Franz and Maria Marc never wavered in their affection for her. The constant flow of postcards that Marc kept up until he left for the war is proof in itself that the artist (who was thirty-two in 1912) took great pleasure in playing his part in

the Prince Jussuf fantasies of the poet, who was eleven years his senior. He was well aware of the deeper meaning of the fantasy, namely, that art – artistic fiction – is the salvation of an imperiled human existence.[21]

In the letter to Marc in which Lasker-Schüler praised his woodcut *Reconciliation,* she referred him to her own recent novel, *Mein Herz* (My Heart, published in 1912), describing it as a self-portrait.[22] In this work, written in the form of letters to Walden, she described her Jussuf persona as a way of transcending the prosaic, everyday metropolitan reality of Berlin. The way to the imaginary Land of Thebes was opened for her by a visit to an Egyptian exhibition at Lunapark, and the writer of the letters, Else Lasker-Schüler, made way for Jussuf, the warlike Prince of Thebes.[23] In kaleidoscopic shifts of scene from the humdrum city – with its own versions of the earthly paradise – to the far-off fantasy land of Thebes, there emerges a proto-Dadaist satire on the Berlin art world that is also, and simultaneously, a despairing view of the abyss that lay beneath the surface of life in Wilhelm II's imperial capital. Full of abrupt shifts of tone, the novel contrives to be both brash and whimsical at the same time:

> Why is one so drawn to the café? A dead body is carried upstairs every night; it can't get any rest. Why stay in Berlin at all? In this cold, barren city.... Children, I'm awfully bored, all whom I loved have been untrue. I feel like an outcast every time I step onto the terrace of our café.... I am the utmost degree of desolation; there is nothing more after me. If only someone would say something sweet to me!... And I can only live on miracles. Think of a miracle, will you, please![24]

The pursuit of the miraculous is a gesture of defiance, and it is the only way to prevail over reality. This is the game that Lasker-Schüler is playing as an artist, both in her books and in her dialogue with Marc. Her hysterical public scenes and her pathetic collapses, as witnessed by Marc, are no mere discordant by-products of the game, to be overlooked if possible: they are the visible traces of art's ceaseless war against the banality of life. Seen from this point of view, Marc's postcards are messages of comfort in the heat of battle – a battle in which Marc was also engaged.

It was in this spirit that Lasker-Schüler received Marc's first greeting, with its message: "The Blue Rider presents his Blue Horse to Your Highness" (plate 1). She told him that the blue horse whirled through her "den," as she called her lodgings, and freed her from oppressive thoughts. A few days later she wrote to Marc that blue was the right color for Jesus of Nazareth; the Philistine, on the other hand, could not endure any color.[25] She ended the letter with her seal, which consisted

of a crescent moon and a star. Within days, she received from Marc, as a New Year's greeting for 1913, *The Tower of Blue Horses* (plate 2). The animals are emblazoned with her crescent and stars and colored all over in her favorite color, blue. Marc's world is thus adorned with all the emblems of transcendental beauty that the poet herself employed.

The dreamworld of the postcards could even accommodate unwelcome events, like the worsening of Lasker-Schüler's illness at Sindelsdorf in 1913. Marc responded to this with a postcard of an exotic female figure meditating in a paradisal landscape (plate 3). The next image he sent her celebrates her complete recovery; it is the image of a mettlesome *Dancer from the Court of King Jussuf* (plate 5). Rejoicing is general, not only at the court of Prince Jussuf - now a king - but in the animal realm, among the blue horses, who dance around a cypress tree on the other side of the letter (plate 4).

The realm of the blue horses was of course Sindelsdorf, and the joy expressed by the two animals was that felt by Franz and Maria Marc, who in the same letter announced their impending arrival in the city where King Jussuf was now holding court. Or, in other words, they would like a heated room in the Pension Modern, on Theresienstrasse, Munich, where Lasker-Schüler was living. Maria Marc recalled: "When we went to see her there, we found her at a table full of tin soldiers, with which she was fighting pitched battles - a substitute for the battles that filled her life. She could never really come to terms with life; she lived in almost continual conflict with people who made her existence a misery because they had no understanding of the unique, fantastic nature of her personality and her poetic gifts."[26]

Marc's painted postcards were a constant solace to her, and they helped her to maintain her fantasy intact. When she left Munich, Marc sent her *The Three Panthers of King Jussuf* (plate 6), and a week later *The Watering Hole on the Ruby Mountain* (plate 7), accompanied by an anxious enquiry as to her well-being in Berlin. At this point, if not before, the special character of Marc's postcards as images of friendship becomes manifest. For the mountain formations in *The Three Panthers of King Jussuf* and in *The Watering Hole on the Ruby Mountain* are unequivocal signs that the Kingdom of Thebes is to be equated with the remote village of Sindelsdorf, in the foothills of the Bavarian Alps.

The corrupt antithesis of this world is Berlin. By taking up a vantage point utterly remote from the fascination as well as the banality of the metropolis, Marc is able to send to his Prince Jussuf images of Thebes that are nearly all images of the secluded paradise of Sindelsdorf. The very next card, *From Prince Jussuf's Hunting Grounds* (plate 8), completes this explicit equation between Thebes and Sindelsdorf by dedicating the hunting grounds of the title, both in the inscription and

through the presence of the crescent and star, to Lasker-Schüler, as a view of her blessed kingdom. On the reverse of the postcard Marc describes himself as a denizen of just such an earthly paradise, living a life of splendid, animal purity with Maria at Sindelsdorf.

Marc has two consistent pictorial metaphors for this rural happiness: mountains and the unreal coloring that he imparts to his animals, as he does to the landscape itself. In its lofty remoteness and fairy-tale coloring, Marc's animal realm thus provides an equivalent for the exoticism of Lasker-Schüler's fairy-tale kingdom. Thebes in Bavaria: this theme is pursued in the next postcard in the sequence, *Prince Jussuf's Lemon Horse and Fiery Ox* (plate 9), the transposition of an idyllic scene of animals on a Bavarian mountain pasture into something fabulously exotic and remote. In this fabulous realm there dwell the "Blue Children," as Marc calls himself and Maria on this postcard.

The same enchanted kingdom is the setting for *The Brood Mare of the Blue Horses* (plate 11): a blue mare and blue foals in a rolling, forested landscape of green meadows, blue hills, and black trees. And that, too, is the home of *The Little Sacred Calf* (plate 12) and – directly inspired by a fresco in a church in South Tirol – the massive image of *The War Horse of Prince Jussuf* (plate 13), on which the Prince rides forth to war.

Marc was able to give expression to the Sindelsdorf idyll even through images of exotic animals, as on the postcard *Monkeys* (plate 14). The animals' uninhibited antics on colorful, flower-strewn mountaintops provide an image of that cheerful insouciance in the face of all social entanglements which the artist had made his own by withdrawing to the country. "People don't deserve us, and that's why we're here at Sindelsdorf." It was not often that Marc expressed himself in such unequivocal and absolute terms. The blend of confessional utterances like this, to a friend whom he now addressed as "sister," with practical, everyday advice, constitutes much of the charm of these postcards.

One highly practical message is conveyed by the card *Fox and Gazelle* (plate 16), which extends Marc's animal theme into the realm of the didactic fable. Just as the gazelle is wary of the prowling fox, the poet should be careful not to let anyone "sponge off" her. The "little treasure" that Marc mentions is the proceeds of a collection promoted on Lasker-Schüler's behalf by writers Karl Kraus and Richard Dehmel, architect Adolf Loos, and others. In this connection an auction was held for her benefit at Schmidt's and Dehmel's Neuer Kunstsalon in early March 1913. Marc had asked his friends from *Der Blaue Reiter* to contribute works for this charitable occasion.[27] He himself painted a

Fig. 6 Franz Marc. *The Dream.* 1913. Kunstmuseum, Bern

picture especially for the auction; titled *The Dream*, this painting bears the inscription "Dedicated to the Prince of Thebes by Fz. Marc" (fig. 6).

Another piece of good advice from Marc was that Lasker-Schüler should have her son moved out of a damp bedroom in his boarding school near Dresden (plate 23). Elsewhere he urged her to take good care of herself and to dream of golden trees and grandmother sheep, as in *Image from Jussuf's Times of Peace* (plate 18), which, once more, he related to his own Bavarian idyll: "Here at Sindelsdorf, we are all so peaceful that we bleat." Accordingly, he exhorted her in his next postcard: "Dear Sister, if your present milieu annoys you too much, mount this dark steed and hasten hither." In the accompanying image (plate 19) the *Black Horse* turns its head toward the blue mountain in the background, as a shorthand equivalent for the dream kingdom of Sindelsdorf, which Marc often called "the Blue Land."[28] The following postcard too (plate 20) must be a reference to Sindelsdorf as a place of sanctuary: it shows a unicorn fleeing from a storm, backed up by Maria Marc's question, "When are you coming?"

The antithesis, which runs through the entire correspondence, between town and country – between the tumult and corruption of Berlin, on the one hand, and the pure, animal arcadia of Sindelsdorf, on the other – finds its climactic expression in *The Dream Rock* (plate 22). Marc sent this postcard on September 21, 1913, from Berlin, where he had been working with Macke and Walden on the installation of the *Erster Deutscher Herbstsalon*, the most important overview of modern art ever shown in Germany, which opened on September 20. The postcard

he sent to Lasker-Schüler the following day betrays no pride of achievement. What it does reveal is Marc's perennial, fascinated loathing of Berlin, which he describes as "a sick background for a dream." He urges Lasker-Schüler to rise from the "grave" of her Berlin lodgings and ascend to the "Dream Rock" of Sindelsdorf: "There it is possible to say nothing and love one another."

This is probably to be understood as Marc's reaction to his friend's admission, in letter number one, just then published, of her "Briefe an den blauen Reiter Franz Marc" (Letters to the Blue Rider Franz Marc), that she was taking opium;[29] but whatever the immediate motive may have been, the antithesis between sickness and health, between the big city and the pacific rural idyll of Sindelsdorf, is entirely typical of Marc's solicitude for his friend's happiness.

Bavaria appears in another guise, not as crystalline blue architecture but as a green landscape of forests and fields, in the last postcard of the series, which was done for Lasker-Schüler's son, Paul Walden. *Ried Castle* (plate 28) was prompted by Marc's purchase of a beautiful house (fig. 7) at Ried, near Benediktbeuern and Kochel am See in Upper Bavaria. It is a symbolic image of his joy at owning a house and a pasture for his beloved animals, and thus becoming the master of his own domain. The house, a spacious villa on the edge of a wood, is transformed in the postcard into a mansion, or even a fortress. Its lord, the Blue Rider, rides out from the castle on his blue horse to hunt deer on his own land: a child's dream of paradise brought to pictorial life in subalpine Bavaria. In *Ried Castle*, Marc has created for himself a fantasy world wholly comparable with Lasker-Schüler's, with its palace and her colorful adventures as Prince, later Emperor, Jussuf in far-off Thebes.

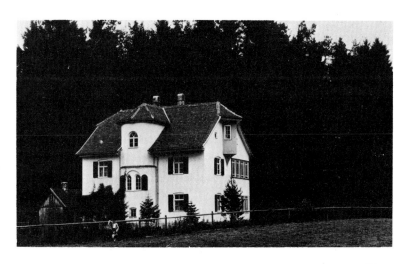

Fig. 7 Franz Marc's house at Ried, near Kochel am See, 1914

17

It was certainly not by accident that Lasker-Schüler used the postcard *Ried Castle* as the frontispiece for her novel *Der Malik: Eine Kaisergeschichte* (Malik: An Emperor's Tale; fig 8). She deliberately employed the Blue Rider's image of his own kingdom to introduce the "Empire" that she depicts in a series of dialogues with Marc himself. This novel is a reworking and continuation of her "Briefe an den blauen Reiter Franz Marc," published in 1913–15, which she must have started work on at the very beginning of her friendship with Marc. In the postcard *Prince Jussuf's Lemon Horse and Fiery Ox* (plate 9) of March 9, 1913, he mentions the forthcoming publication of the first of these open letters in the periodical *März*, yet they did not begin to appear until September, in the major Expressionist journal, *Die Aktion*.

The "Briefe" may well be seen as Lasker-Schüler's poetic answer to Marc's postcards; at the same time they form a continuation of her epistolary novel of 1912, *Mein Herz*. In the earlier book, Jussuf was still mostly based in Berlin and became a Prince in Thebes only intermittently. Now, however, he left his Berlin "den" to reign the whole time in Thebes. Taking her cue from Marc, who responded in his postcards to the stimulus and irritant of Berlin by retreating into his own arcadian animal realm, Lasker-Schüler now carried through her own final exodus from Berlin and had herself crowned Emperor, or Malik, in Thebes. Prince Jussuf's coronation as Emperor Jussuf Abigail I, together with all the festive preparations and a chronicle of his reign, forms the theme of the "Briefe."

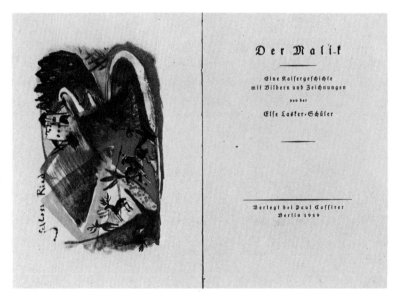

Fig. 8 Franz Marc. *Ried Castle*. Frontispiece to Else Lasker-Schüler, *Der Malik* (Berlin, 1919)

Marc's role in the letters is a twofold one. As the Blue Rider, he is a sort of court painter in Thebes, whose postcard greetings give great delight: "And I feel like turning cartwheels, my blue Franz, because we talk as friends ['du' sagen] and I want to do I don't know what on mornings when your wondrous postcards come!"[30] That comes in letter number two. By the next letter, however, Marc has become a biblical figure in his own right, as Prince Reuben of Cana, half brother to Jussuf.[31]

According to the Bible (Genesis 37:21-22), Reuben, alone among the sons of Jacob, was well disposed toward his half brother Joseph – with whom, as Jussuf, Lasker-Schüler identified herself. By giving Marc the name of the biblical figure who saved Joseph's life, she was expressing her gratitude to him and to his wife for standing by her in her hour of greatest need, when she, sick and impoverished after the divorce from Walden, must have felt utterly alone. By hailing Marc as her half brother, she was also alluding to his ancestry: he was descended from a Jewish family that became assimilated in the late eighteenth century and married into the Bavarian nobility.[32] As Prince Reuben of Cana, Marc is integrated into Jussuf's imperial career in the letters that follow. Maria Marc, too, under her pet name of Mareia, has a place in the saga as Reuben's consort and gives her name to the second city of the kingdom of Thebes.

Owing to the delay in publication, Marc's first mention of the "Briefe an den blauen Reiter Franz Marc" is on the postcard *The Dream Rock* (plate 22), of September 21, 1913. The letters subsequently became a central theme of his private correspondence with the author. Marc was clearly delighted by his new public role as the "Blue Rider" and Prince Reuben. One may well wonder what Kandinsky thought of his friend's public assumption of the title of "the" Blue Rider. There is no mention of it in the correspondence between the two men.

A number of the postcards that followed, such as *Elephant* (plate 23) and *From the Ancient Royal City of Thebes* (plate 24), contain exotic motifs that locate them firmly in the Egyptian context; which is no doubt why Lasker-Schüler immediately found a place for them within her Theban kingdom. *Elephant*, she wrote, "will be printed on the flag of my city." In letter number twenty, *From the Ancient Royal City of Thebes*, which harks back to earlier Arab motifs in Kandinsky's work and also prefigures Macke's and Klee's travels in Tunisia,[33] is assigned a place of honor "in the vestibule of my palace, for all the people to see. The many hues of the picture infused the twilit city with color, as my Somalis bore it through the streets."[34]

The vibrant colors of Marc's postcards became a theme in letter number seven, in which Lasker-Schüler thanked him for the card

entitled *Amerindian Horses* (plate 21) and gave him a commission: "Franz, paint me a green sheep. There is nothing so outlandish left in the world, except me."[35] The wish for a green sheep was a natural consequence of Marc's green, blue, red, and lemon-yellow horses, his fiery ox, his green chamois, and his blue panthers. She had already given a full account of this animal fantasy world in letter number two, in which she said of the animals in the "wondrous postcards," in particular of those in *The Three Panthers of King Jussuf* (plate 6) and *The Tower of Blue Horses* (plate 2): "The big cats are the sovereign beasts. The panther is a wild gentian, the lion a dangerous larkspur, the tigress a raging, shimmering, yellow maple. But your blessed blue horses are all whinnying archangels and gallop straight into Paradise, and your holy, sanctified llamas and hinds – and calves – all rest in consecrated groves. Many of your priestly animals smell of milk. You rear them yourself within the frame. Reverend, blue High Priest!"[36]

As creator of this paradisal alternative universe, on which Lasker-Schüler builds in her own fiction of Jussuf and his kingdom, Marc the High Priest is asked in letter number five for his opinion of the prosaic megalopolis, Berlin: "I would rather be a cannibal than chew the cud of sobriety, over and over; O Blue Rider, I am the only saint in this alien city. No one here ever goes to Heaven. Just cross the Kurfürstendamm, turn the corner onto Tauentzienstrasse; can you imagine, can you conceive, that one single person you see will go to Heaven? Tell me, Blue Rider, will I go to Heaven?"[37]

One can already see the dual nature of the role of redeemer that Marc would play in Lasker-Schüler's imagination, both through his own purity of character and through the paradisal vision embodied in his art. What also becomes apparent is the profound affinity between her writing and the artistic and personal credo that emerges from his famous postcards to her. On April 12, 1915, in one of his letters from the Western Front, he wrote these significant words: "The profane humanity all around me (and male humanity above all) never aroused an emotional response in me; but the animal's intact vital feeling caused all that was good in me to resonate. And from the animal an instinct led me toward the abstract."[38] From the profanity of mankind to the untainted purity of animals, and thence to landscapes conceived in abstract forms: this had been the message of Marc's postcards to Lasker-Schüler. As an already corrupted inhabitant of the corrupt city, she was thereby encouraged to create an alternative, purified reality of her own, in the shape of her remote and beautiful Empire of Thebes.

To describe imaginative activity of this sort as escapist is not an adequate response. The Empire of Thebes is clearly a polar antithesis to the German Empire that had Berlin as its unholy capital. Lasker-

Schüler's critique of Emperor Wilhelm II's Berlin is perhaps less explicit here than in her earlier epistolary novel, *Mein Herz;* even so, the subversive intent of pitting a new Empire, governed by artists, against an established Empire ruled by a potentate with artistic leanings, is constantly evident in such provocative remarks as "No one here ever goes to Heaven."

In his essay "Geistige Güter" (Spiritual Assets), at the beginning of the *Almanach "Der Blaue Reiter,"* Marc too had taken a strong anti-imperial line by coming out in support of Hugo von Tschudi, director of the Nationalgalerie in Berlin, who had been dismissed by Wilhelm II. The German Empire, wrote Marc, was interested only in material assets, such as new colonies or advances in technology; spiritual assets, as in the realm of art, were utterly unwanted.[39] It was to counter this general dearth of interest in things of the spirit, and in new "spiritual assets" in particular, that the *Almanach "Der Blaue Reiter"* was published.

In the common struggle to promote "spiritual assets," Marc was far less concerned than Kandinsky with furthering any one specific form of art. Thus, Kandinsky rejected the work of the Berlin group *Die Brücke* (The Bridge) as lacking in "spirituality" and also in formal purity; but Marc, perhaps surprisingly, prized it precisely because it concerned itself with "modern life and the big city." Ugly it might be, but it was "full of deeper meaning and realism."[40] In his introductory article for the Almanach, he accordingly included these Berlin Expressionists in the category of Germany's *Wilde*, those "wild ones" (or *fauves*) who represented a still unorganized force in the fight against established authority and for new ideas.[41] Kandinsky concerned himself primarily with the elevated goal of "The Spiritual in Art"; Marc still turned back, as it were, to look at the creature in need of redemption. Hence his ability to see the Berlin Expressionists as comrades in arms, fighting for a new, true, living art.

It was therefore no accident that Prince Jussuf, the "Wild Jew," a figure straight out of Berlin's literary Expressionism, became Marc's half brother. Thus, the two centers of modernism, Berlin and Munich, which Kandinsky, in the *Almanach "Der Blaue Reiter,"* proclaimed irreconcilable – and far from equal – polar opposites, appear in the light of the friendship between Marc and Lasker-Schüler as harmonious contrasts within a common struggle against the dominant forces of banality and materialism.

Marc believed that even as a soldier in World War I he was serving his own spiritual ideal. He hoped – wrongly, as he soon discovered – that the war would bring about a purification of the old Europe and lead to a spiritual renewal.[42] Lasker-Schüler gave her answer to that

idea in the continuation of her Jussuf fiction in the novel *Der Malik*. In his grief at the death of his friends in the western war, Emperor Jussuf Abigail puts an end to his own life. The end of Wilhelm II's Empire is thus also the end of Jussuf's Empire.

Marc's postcards to Lasker-Schüler point straight to the center of his own artistic concerns and of the spiritual and intellectual issues of his time. These poetic, intensely private messages and the responses that came, no longer private, in the "Briefe an den blauen Reiter Franz Marc" reshape the whole map of early modernism in Germany. Where observers have tended to see only contrast, these documents reveal harmony. They clearly show the integrative power of Marc, who, from his apparent isolation in Sindelsdorf, was able to make his presence felt in Munich and also, as an emissary of *Der Blaue Reiter*, in Berlin, handling fellow artists, publishers, dealers, and museum directors with great skill and assurance.

The postcards are a crowning achievement in Marc's work. They encapsulate all his experience of pictorial form, and all he had learned from international modernism, from Cubism, Futurism, and especially Delaunay's Orphism. They also give pictorial expression to a whole series of statements on life and the world. These were statements made to one who was a kindred spirit, who felt and thought much as he did himself. Like Marc, Lasker-Schüler revered animals as pure beings in and for their wildness. Like Marc, she loved the color blue as the precious garment of all that is mysterious, sublime, sacred, spiritual, and transcendental. And, like him, she saw mountains, towers, the moon, and the stars as pointers to an ideal world above, something supernal, remote, and pure.[43]

Yet in spite of these affinities, the postcards are first and foremost a reflection of Marc's own unique world of images. This becomes apparent in their references to earlier works and projects, and in their function as preliminary studies for new paintings. Thus, Marc's major painting, *The Tower of Blue Horses,* was done only a few weeks after the postcard that bears the same title. When seen in the context of his work as a whole, the cards furnish a decisive key to the understanding of Marc's pictorial universe.

Thus, we can see his works as fantasy images of solace, a partial, but by no means exclusive interpretation that corresponds to his own view of the postcards. We are in a position to state, with considerably more certainty than hitherto, that whenever animals turn to look at distant blue mountains in Marc's works (see plate 19), they do so in a yearning for some happier world. Whenever animals rest on blue, crystalline mountains, they are in a remote paradise of their own (see plate 22). Whenever animals stand out against a blue sky, or in their own blue-

ness fill the upper part of the painting, they are growing upward into a transcendent, spiritual world, as in *The Tower of Blue Horses* (plate 2) or in *Ibex* (plate 25), which simultaneously evokes death and hope through an image of a creature on a mountain peak. Marc's blue animals may sometimes come close to flowers (see plate 4), or they may turn – in some Paradise Regained, in which Creation seems reconciled with itself – into enchanted jewels set in precious stones (see plates 7, 15, 17) or into symbols of childlike innocence (see plate 12). The postcards, with their message of solace, show Marc's work, much more clearly than has been hitherto recognized, to be a vision of a spiritualized, paradisal existence to which the human individual feels a nostalgic sense of belonging.

However, animals in Marc's work do not always simply feel and act like human beings: "Iphigenia as a dog," as one commentator cuttingly put it.[44] Rather, they can *be* human beings; or conversely, human beings can be shown as animals. The prancing *Two Blue Horses* (plate 4), as we learn from the accompanying message, illustrate Franz and Maria Marc's rejoicing; the leaping monkeys stand for their carefree life at Sindelsdorf. In *From Prince Jussuf's Hunting Grounds* (plate 8), Marc describes himself and Maria as "the pure beasts," an animal equivalent of those "wild ones" whom Marc and the artists of his generation considered to be the renewing force of the twentieth century.

Dual Gifts

Marc's postcards to Lasker-Schüler provide an especially telling instance of the closeness that can exist between poetry and painting. They show the artist bringing his own imagery close to the conceptual and imaginative world of the poet; and therein lies his literary gift. Through purely linguistic means, such as the poetic titles of the images and the closely related manner of the letters themselves; through the inclusion of Prince Jussuf's symbols, crescent moon, stars, and open heart; and finally, through a constant, carefully maintained aura of preciousness and sumptuousness (silver paper is pasted on some of the postcards, for example), Marc contrived to make Prince Jussuf's fairy-tale world entirely at home in his own Sindelsdorf arcadia. Marc, the painter-poet who had once wanted to study philology and whose letters hold an established place in German literature, could create a pictorial extension of Lasker-Schüler's work only because his own pictorial world had such a close affinity to her literary imagery. The poet Klabund got it just right when he wrote in 1913: "Else Lasker-Schüler's art is very closely related to that of her friend, the Blue Rider

Franz Marc. All her thoughts are clad in fabulous colors, and they slink along like many-hued animals. Sometimes they emerge from the forest into the clearing like shy red deer."[45]

Lasker-Schüler found Marc's postcard images so uncannily congenial to her vision that in 1914 she used three of them – not the most exotic, but those that allude to a Bavarian version of Thebes – as color plates in her book of stories *Der Prinz von Theben* (The Prince of Thebes). The illustrations in the text of the book were her own. To this end she had asked Marc for a letter recommending her drawings to the publisher, Kurt Wolff, and promised to show him some specimens. Marc encouraged her: "Do send us your pictures to look at, and draw postcards for us too, pictures of yourself and your Court; will you do it?" She often put drawings into her postcards and letters to Marc, and there exist a number of purely pictorial postcards from her to him (fig. 9).

Fig. 9 Else Lasker-Schüler. *Jussuf and his Chieftains.* Pencil drawing on a postcard to Franz Marc. Franz Marc Museum, Kochel am See

She had loved drawing all her life. She wrote to Richard Dehmel: "I have painted since childhood...I wrote a lot of poetry even as a small child, but then I tried to force everything down with a paintbrush."[46] Artistic talent ran in her family. Her eldest brother, Alfred (born January 21, 1858), was a painter in Hamburg; her uncle, Max Schüler, was a painter in Frankfurt. In the early years of her marriage to Lasker, from 1894 onward, she had a studio of her own in Berlin, in the Tiergarten district, and studied with the painter Simon Goldberg. Lasker-Schüler was thus far from a mere amateur in the field of visual art, and she was known in *Der Sturm* circles as a poet who also drew. Her drawing, like her writing, seems often to have been done in coffeehouses, mostly in writing ink and colored pencils on ordinary paper.

One symptom of her dual talent is her constant endeavor to turn her books into picture books by including drawings, her own and other people's, and photographs. The first illustrated edition she succeeded in publishing was *Mein Herz,* published in Munich in 1912. It contains twenty-one full-page drawings by her, her portrait by Karl Schmidt-Rottluff (fig. 10), and a photograph of her as the Prince of Thebes (fig. 2). The publications that followed, *Der Prinz von Theben,* "Briefe an den blauen Reiter Franz Marc," and *Der Malik,* were also adorned with numerous drawings by her, augmented in the case of *Der Prinz von Theben* and *Der Malik* by color reproductions of Marc's work. His postcard *Ried Castle* appeared as a color frontispiece to *Der Malik* (fig. 8 and plate 28), in order to present the novel as their joint work, an intention further emphasized by the beautiful dedication: "To my unforgettable Franz Marc / THE BLUE RIDER / in all eternity."

24

Fig. 10 Karl Schmidt-Rottluff, *Else Lasker-Schüler.* Drawing in *Der Sturm,* September 1912

Marc's last postcard greeting to Lasker-Schüler, as we have seen, was *Ried Castle* (plate 28), of April 1914. He had very few months of peace left in which to enjoy his newly acquired house at Ried. On August 6 he was caught up in the general mobilization and sent to the Western Front. (The widespread view that Marc, like many of his generation, volunteered for the war, is inaccurate.) He continued his correspondence with Lasker-Schüler, with long gaps, while he was at the Front. Her anxious letters enquiring after his well-being have survived, but there seem to have been no more painted postcards.[47] Fifteen more of her "Briefe an den blauen Reiter Franz Marc" appeared in the summer of 1914; the last came in August 1915.

The novel *Der Malik,* which embodies a continuation of these letters, appeared in the periodical *Neue Jugend* after Marc's death in battle on March 6, 1916. The story that began so poetically, with Jussuf's departure from the "den" of a rented room in Berlin to assume supreme rule over the Empire of Thebes, ends with his lonely suicide, echoing the catastrophic slaughter of World War I. An exotic fairy tale has turned into a European nightmare; a novel about art and artists ends as an antiwar novel.[48]

Marc remains a central figure in this elaboration of the "Briefe," in which he appears under the names of Marc of Cana, Prince Reuben Marc, and the Blue Rider. For the first time, his knightly appearance is described in detail: "In body, Reuben was tall, with a tender, majestic stillness and powerful, sun-bright beauty. His eyes were brown, like the wood of the sweet tree-bark."[49] Reuben's impending death in battle is foretold to Jussuf: "Abigail, rise up, for thou fearest for Reuben, thy dear brother; the star at his temple fadeth."[50] When Reuben dies, for Jussuf a part of God dies: "My brother, the Blue Rider was God; who is God now?"[51]

Marc appears as the Elect of God in Lasker-Schüler's moving obituary for him, published in the *Berliner Tageblatt* on March 6, 1916. She elevated him into a mythical figure, who had shed the burdens of earthly life and regained the paradise that was lost: "The Blue Rider has fallen, a mighty, biblical figure about whom there hung a fragrance of Eden. Across the landscape he cast a blue shadow. He was the one who could still hear the animals speak; and he transfigured their uncomprehended souls." In her conclusion she praised his postcards as unique visions of paradise: "I never saw a painter paint with such seriousness, or with such gentleness. He called his animals 'Lemon Ox' and 'Fiery Buffalo,' and a star shone from his temple. But even the beasts of the wilderness began to grow like plants beneath his tropical

hand. By a magic spell, he transformed tigresses into anemones, and leopards he arrayed in all the panoply of stocks in bloom."[52]

The prose text of the obituary was followed by a poem which depicted the Blue Rider setting off to war. These two elements became a trilogy in Lasker-Schüler's 1917 volume of collected poems, *Gesammelte Gedichte*, where they are followed by a poem dedicated to "my beloved half brother, the Blue Rider," and titled "Gebet" (Prayer), in which the poet prays that the artist may return to the almighty presence of God. The two embracing figures in her drawing for the cover of this collection – in the edition published in 1920 (fig. 11) – are Marc, in his biblical role of Prince of Cana, and his Jussuf, whom he is consoling. The dedication reads: "The cover picture, drawn by me, I give to Franz Marc."

Fig. 11 Else Lasker-Schüler. *Reuben and Jussuf Embrace.* Drawing for cover of her *Gesammelte Gedichte* (Berlin, 1920)

After Marc's death, Lasker-Schüler remained in correspondence with Maria Marc, who helped her with money. On August 24, 1918, she asked Maria if she would agree to a complete publication of Marc's postcards, which were then hanging in the poet's rented room in Berlin.[53] This idea, suggested by the pianist Leo Kestenberg,[54] came to nothing, perhaps because Lasker-Schüler was so hard-pressed financially as a result of her son's illness that in 1919 she was forced to sell the postcards to the Nationalgalerie in Berlin for 8,300 marks. On July 15, 1919, Maria Marc wrote to the distinguished director of the Nationalgalerie, Ludwig Justi – who had just bought Marc's painting *The Tower of Blue Horses* – that his assistant, Dr. Kaesbach, had told her "that the Department of Drawings is also buying my husband's postcards to Frau Lasker-Schüler. I can think of no more welcome way for my husband's art to be represented in the Berlin gallery. I would like to thank you for the warmth of your interest."[55] Justi immediately placed a selection of the cards on show in the new building of the Nationalgalerie, the former palace of the crown prince. He concluded his detailed appreciation of them with the words: "The whole is a delightful poem, combining a loving observation of Nature with a free play of form."[56]

The sale of the postcards had an epilogue, two years later, that was absolutely typical of Lasker-Schüler. She bitterly regretted selling the works, almost from the first, and on July 9, 1921, she wrote to the Commission of the Nationalgalerie and, in an undated letter probably written at the same time, to Justi as well. Both letters are requests to be allowed to buy back Marc's postcards; that to Justi runs as follows:

> It looks as if I am always grumbling, but I have been to the museum at least ten times to speak to you. If I had found a person to lend me money for my sick son, Franz Marc's pictures would never have been sold to the Nationalgalerie for eight thousand 300 marks. I would have

lent them to the gallery. I have *no right* to sell the pictures, because they were addressed to my son as well as to me. And now I don't know how it's all going to end. Franz Marc wanted to give us *both* something. And now my boy is not even paid the basic courtesy of leaving the *writing* in place, [of being able to see] that these incomparable cards were drawn for his mother. Even some Munich people noticed it. That is how artists are blocked in this country. I want to buy the pictures back. Where are the others? There were 29 in *all.* 1 disappeared. I want to proclaim it to the world! I don't blame you in the least, Herr Geheimrat; with *my* pictures too it was meant *differently.* Please answer me. I shall soon have earned enough money. Yours sincerely, Else Lasker-Schüler.[57]

At the top of the page, before the salutation, are the words: "If Franz Marc knew of this!"

Justi's reply to this extraordinary request can hardly have been an encouraging one. There exists a copy of his negative answer, dated May 28, 1919, to a letter from a Berlin lawyer, Fritz Grünspach, who had written to him on Lasker-Schüler's behalf. Writing again on June 9, Grünspach referred to an enclosed letter from the poet's friend Elfriede Caro which expressed the fear that Lasker-Schüler might kill herself in her grief at the loss of the postcards. Grünspach took this fear quite seriously: "For this reason I feel that it is no more than my human duty to request you urgently to find some form of settlement that will return the pictures to my client, who appears to attach the utmost vital importance to their possession, not for material but purely for personal and psychological reasons."[58] After further consultations with the Ministry, Justi could only repeat his previous reply: "The pictures by Franz Marc, obtained by purchase from Frau Lasker-Schüler, have become state property and therefore cannot be returned."[59]

However painful this may have been for Lasker-Schüler, she maintained good relations with the Nationalgalerie thereafter. On November 25, 1930, she wrote to Baroness von der Heydt asking her to intervene with the Nationalgalerie authorities to induce them to accept a gift of works by her son Paul, who had died three years previously. In this letter she once more mentioned Marc's postcards and her own drawings, which were already in the Nationalgalerie collection: "I have 29 pictures, postcards from the Blue Rider, our Franz Marc (which he drew for me and for my son Paul), there in the gallery. (Unfortunately I had to accept something for them.) The directorate bought my own earliest illustrations, too."[60]

Both collections of works, Marc's twenty-eight postcards and Lasker-Schüler's twenty-three drawings, were removed from the Nationalgalerie on July 7, 1937, by the Nazis as part of the campaign

against "degenerate art" (*Entartete Kunst*). Three postcards by Marc, *The Tower of Blue Horses* (plate 2), *The Three Panthers of King Jussuf* (plate 6), and *The Dream Rock* (plate 22), were sent to Munich on July 9, together with Lasker-Schüler's drawings mounted on fifteen pieces of card, for the exhibition *Entartete Kunst*, but were probably not put on show.[61] Subsequently, all of Marc's postcards and Lasker-Schüler's drawings were moved out of the Nationalgalerie to the storehouse of "degenerate art" at Schloss Niederschönhausen in Berlin.

In February 1939 Sofie and Emanuel Fohn, a man and wife who were both painters and collectors, were able to extract twenty-two Marc postcards and six Lasker-Schüler drawings, together with other works of "degenerate art," from the Nazi authorities in exchange for works by German Romantic artists, thus saving them from an uncertain future and possible destruction.[62] As the Sofie and Emanuel Fohn Donation, the works entered the Bayerische Staatsgemäldesammlungen in Munich in 1965. The remaining six Marc postcards and seven Lasker-Schüler drawings are now once more in the drawings collection of the Nationalgalerie, part of the Staatliche Museen zu Berlin, GDR. In the present book, Marc's postcards, now divided between two collections, are reunited.

Notes

Works listed in the Bibliography (p. 103) are referred to here in abbreviated form. DLA stands for Deutsches Literaturarchiv, Marbach am Neckar.

1. Marc, *Botschaften*, p. 6.
2. Marc, *Botschaften*, p. 5.
3. Quoted in Lankheit, 1970, p. 108.
4. DLA, 81.194/2.
5. Marc to Kandinsky, December 23, 1912; Kandinsky and Marc, p. 205.
6. Marc to Klee, December 18, 1912; Lankheit, 1970, p. 108.
7. Marc to Kandinsky, December 23, 1912; Kandinsky and Marc, p. 204.
8. Maria Marc to Elisabeth Macke, January 21, 1913; Macke and Marc, pp. 146-47.
9. Quoted in Klüsener, p. 144.
10. Quoted in Bauschinger, p. 125.
11. Quoted in Pfäfflin, pp. 11-12, 23-24.
12. Gottfried Benn, *Gesammelte Werke*, vol. 1 (Wiesbaden, 1959), pp. 537-38.
13. The story of Lasker-Schüler's arrest in Munich in the early days of World War I was told by Wieland Herzfelde; see Bauschinger, p. 37.
14. We owe the story to Emmy Ball-Hennings; see Bauschinger, p. 37.
15. Lasker-Schüler, postcard to Marc, August 22, 1913 (DLA 81.195/21).
16. Else Lasker-Schüler, "Wauer-Walden via München...," *Der Sturm*, vol. 2 (1911-12), pp. 575-76; Lasker-Schüler, *Gesammelte Werke*, vol. 4, p. 266.
17. Marc mentioned Lasker-Schüler in a letter to Klee on December 14, 1912; see Hüneke, p. 253. On November 14, 1913, Lasker Schüler wrote to Marc from Munich after a highly enjoyable meeting with Paul and Lily Klee (DLA, 81.196/9). In letter no. 5 of the "Briefe an den blauen Reiter Franz Marc," she sends greetings to others of the Blue Rider's friends, including Campendonk, Werefkin, and Jawlensky.
18. Maria Marc to Elisabeth Macke, January 21, 1913; Macke and Marc, p. 147.
19. Maria Marc to Elisabeth Macke, January 21, 1913; Macke and Marc, pp. 147-48. For Maria's apologetic letter to Kandinsky of January 19, 1913, see Kandinsky and Marc, p. 209.
20. Postscript by Franz Marc to letter from Maria Marc to Elisabeth Macke, January 21, 1913; Macke and Marc, p. 149.

21. See Angelika Koch, *Die Bedeutung des Spiels bei Else Lasker-Schüler im Rahmen von Expressionismus und Manierismus* (Bonn, 1971), and Bauschinger, p. 94 ff.
22. Lasker-Schüler to Marc, November 9, 1912 (DLA, 81.194/1).
23. Else Lasker-Schüler, *Mein Herz*, in *Gesammelte Werke*, vol. 2, p. 21.
24. Ibid., p. 30.
25. Lasker-Schüler to Marc, December 15, 1912 (DLA 81.194/5).
26. Marc, *Botschaften*, p. 7.
27. See Macke and Marc, pp. 148, 153, and Hüneke, pp. 276 – 77. For the outcome of the appeal for donations for Lasker-Schüler, see also Karl Kraus, in *Die Fackel*, no. 389/390 (December 15, 1913), p. 15 ff.
28. See Lankheit, 1986, p. 1.
29. Lasker-Schüler, "Briefe an den blauen Reiter Franz Marc," p. 85.
30. Ibid., p. 87.
31. Ibid.
32. See Lankheit, 1970, p. 11.
33. See Johannes Langner, in *Delaunay und Deutschland*, no. 154.
34. Lasker-Schüler, "Briefe an den blauen Reiter Franz Marc," p. 96.
35. Ibid., p. 91.
36. Ibid., p. 87.
37. Ibid., p. 88.
38. Marc to Maria Marc, April 12, 1915; Marc, *Briefe aus dem Feld*, p. 63.
39. *Almanach "Der Blaue Reiter*," pp. 21 – 22.
40. On the debate between Kandinsky and Marc in January – February 1912 on the subject of *Die Brücke*, see Kandinsky and Marc, pp. 112, 128, 130. Marc's letter to Kandinsky (February 4, 1912) is quoted from the same source.
41. *Almanach "Der Blaue Reiter*," p. 28 ff.
42. For Marc's views on the war, see his essays in *Schriften*, p. 155 ff.
43. See Guder, Webb, and also Brigitte Lühl-Wiese, *Georg Trakl-Der Blaue Reiter: Form- und Farbstrukturen in Dichtung und Malerei des Expressionismus* (Münster, 1963), pp. 55 ff., 90 ff., 132 ff.
44. Johannes Langner, in *Franz Marc 1880 – 1916*.
45. Quoted in Pfäfflin, p. 29.
46. Quoted in Bauschinger, p. 211, who provides the fullest critical appreciation of Lasker-Schüler's drawings yet published. See also Schuster, pp. 132 – 34.
47. Two postcards written in 1915, which Lankheit's catalogue (nos. 796, 797) describes as possibly greetings addressed to Lasker-Schüler, were acquired by the Nationalgalerie in 1920 from Admiralsrat Dr. Beggerow,

of Berlin; see *Expressionisten*, nos. 370, 371. Lasker-Schüler herself invariably refers to a total of twenty-eight (or twenty-nine) cards from Marc.
48. On *Der Malik* as an antiwar novel, see Bauschinger, p. 151 ff.
49. Else Lasker-Schüler, *Der Malik*, in *Gesammelte Werke*, vol. 3, p. 49.
50. Ibid., p. 84.
51. Ibid., p. 94.
52. Lasker-Schüler's obituary for Franz Marc is reprinted complete, but without giving the source, in *Expressionisten*, p. 142 ff. Lankheit, 1960, p. 77 ff., gives a later version of the text and also prints the poem "Als der blaue Reiter war gefallen," written in 1917 to lament the supposed loss of Marc's painting *Animal Fates*. For Lasker-Schüler's numerous dedications of individual poems to Marc after his death, see Lasker-Schüler, *Briefe*, vol. 2, p. 268.
53. Lasker-Schüler to Maria Marc, August 21, 1918 (DLA 81.198/6).
54. On Leo Kestenberg, see Lasker-Schüler, *Briefe*, vol. 2, p. 327.
55. Maria Marc to Ludwig Justi, July 15, 1919 (Nachlass Justi 13, copy in Archiv der Nationalgalerie, Berlin, GDR).
56. Ludwig Justi, *Deutsche Zeichenkunst im neunzehnten Jahrhundert: Ein Führer zur Sammlung der Handzeichnungen in der Nationalgalerie*, 2nd ed. (Berlin, 1922), p. 117.
57. Lasker-Schüler to Ludwig Justi, undated (Archiv der Nationalgalerie, Berlin, GDR, Generalia 10, Bd. 12 zu 806/21). Filed under the same shelfmark is a letter from Lasker-Schüler to the Commission der Nationalgalerie, dated July 9, 1921, in which she writes of her "fraternal friendship" for Marc and asks again "for the return of these keepsakes, which are dear to me and which were also painted for my child."
58. Fritz Grünspach to Ludwig Justi, June 9, 1921 (Archiv der Nationalgalerie, Berlin, GDR, Generalia 10, Bd. 12 zu 806/21).
59. Ludwig Justi to Fritz Grünspach, May 28, 1921 (Archiv der Nationalgalerie, Berlin, GDR, Generalia 10, Bd. 12 zu 806/21).
60. Lasker-Schüler to Baronin von der Heydt, November 25, 1921 (Archiv der Nationalgalerie, Berlin, GDR, Generalia 10, Bd. 12 zu 806/21).
61. Archiv der Nationalgalerie, Berlin, GDR, file "Entartete Kunst," p. 1.
62. Archiv der Nationalgalerie, Berlin, GDR, Acta Spec. 24, Bd. 9 zu 942/40. See Kurt Martin, in Fohn, p. 2 ff.

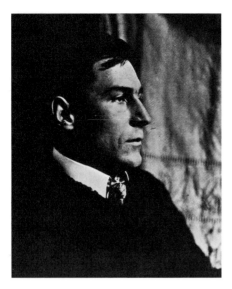

Franz Marc (photographed c. 1913)

Franz Marc was born in Munich on February 8, 1880, the second son of the painter Wilhelm Marc and his Alsace-born wife Sophie, *née* Maurice. After graduating from a local *gymnasium,* he did one year's military service before studying painting at the Kunstakademie in Munich. In 1903 he went to Paris, where he greatly admired the works of the Impressionists. In 1907 he visited Paris again and became acquainted with the work of Gauguin and Van Gogh. In 1909 he moved to Sindelsdorf with Maria Franck, later his wife. In 1910 his friendship with the painter August Macke began. In 1911 he became a member of a Munich exhibiting society, the Neue Künstlervereinigung, and from the summer of that year worked with Wassily Kandinsky on the preparation of the *Almanach "Der Blaue Reiter."* In December he and Kandinsky left the Neue Künstlervereinigung and organized the first *Der Blaue Reiter* exhibition, at the Moderne Galerie Thannhauser in Munich. The second show was held at a bookstore gallery, Buch- und Kunsthandlung Goltz, in March 1912. In May of that year the *Almanach "Der Blaue Reiter"* was published. In October he made his third trip to Paris, this time with Macke, during which he met and was influenced by the painter Robert Delaunay and his "Orphism." In Berlin, in December 1912, came the beginning of his friendship with Else Lasker-Schüler, who traveled with Franz and Maria Marc to Sindelsdorf and Munich in January 1913. It was at this time that he began sending his postcard greetings to "Prince Jussuf." In September 1913 he was a principal organizer, with Macke and Herwarth Walden, of the *Erster Deutscher Herbstsalon* (First German Fall Salon) in Berlin. In April 1914 he moved into a house of his own at Ried, near Kochel am See in Upper Bavaria. Following his induction in August 1914, he served on the Western Front. He was killed in the siege of Verdun on March 4, 1916. In 1937 he was blacklisted as a "degenerate artist," and 130 of his works were confiscated from German museums.

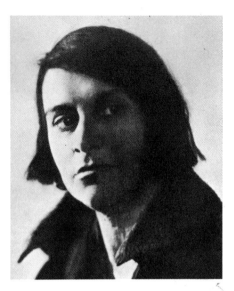

Else Lasker-Schüler (photographed in 1912)

Else Lasker-Schüler was born in Elberfeld on February 11, 1869, the sixth child of the broker and merchant banker Aaron Schüler and his wife Jeannette, *née* Kissing. Her grandfather was a chief rabbi. In 1884 she married a doctor, Berthold Lasker, and moved to Berlin, where she studied painting under Simon Goldberg. In 1899 she published her first poems, gave birth to her son Paul (1899–1927), and became friends with the poet Peter Hille (1854–1904). Also in 1899, she met Georg Levin, composer and writer, on whom she bestowed the new name of Herwarth Walden. Divorced from Lasker in 1903, in November of that year she married Walden, who in 1910 founded the periodical *Der Sturm* and in 1912 the gallery of the same name, thus giving modernism its principal forum in Berlin. The name *Der Sturm* was another invention of Lasker-Schüler's. In 1909 she wrote her play *Die Wupper*; in 1910 she separated from Walden, and they were divorced in November 1912. In December 1912 she became friendly with Franz Marc, and in January 1913 she traveled with Franz and Maria Marc to Sindelsdorf and Munich. The "Briefe an den Blauen Reiter Franz Marc" were written from March 1913 onward, and published in *Die Aktion*. Her friends included the writers Martin Buber, Richard Dehmel, and Karl Kraus, the poets Theodor Däubler, Gottfried Benn, Georg Trakl, and Franz Werfel, and the architect Adolf Loos. In 1914 she published *Der Prinz von Theben* (The Prince of Thebes), in 1917 *Gesammelte Gedichte* (Collected Poems), and in 1919 *Der Malik* (Malik). In 1932 she was awarded the Kleist Prize, and in 1933 her works were banned. In April of that year she was attacked and knocked down by Nazis in Berlin, and she fled to Switzerland. In 1934 she traveled to Egypt and on to Palestine before returning to Switzerland. She settled in Palestine in 1937 and lived in Jerusalem in great poverty. Her last collection of poems, *Mein blaues Klavier* (My Blue Piano), was published in 1943. She died in Jerusalem on January 22, 1945, and is buried on the Mount of Olives.

Postcards to Prince Jussuf

1

The Blue Rider with His Horse
Der Blaue Reiter mit seinem Pferd
India ink and writing ink
Letter, December 8 (?), 1912

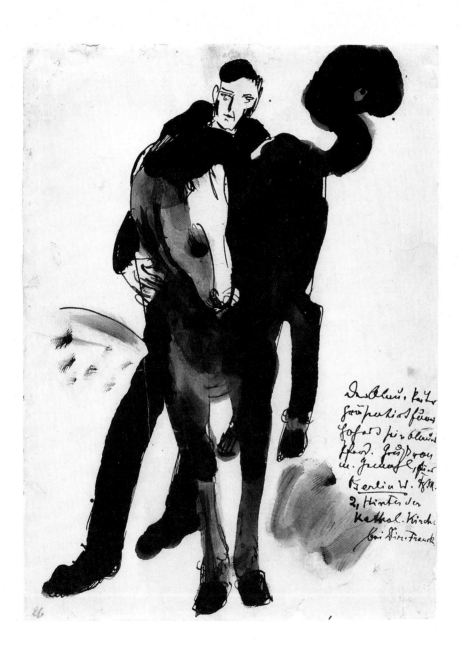

2

The Tower of Blue Horses
Der Turm der Blauen Pferde
India ink and gouache
Postcard, New Year, 1913

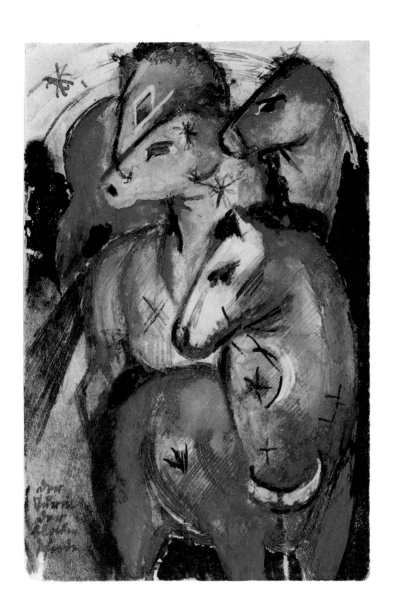

3

Yellow Seated Female Nude

Sitzender gelber Frauenakt

India ink and watercolor

Letter, January 22, 1913

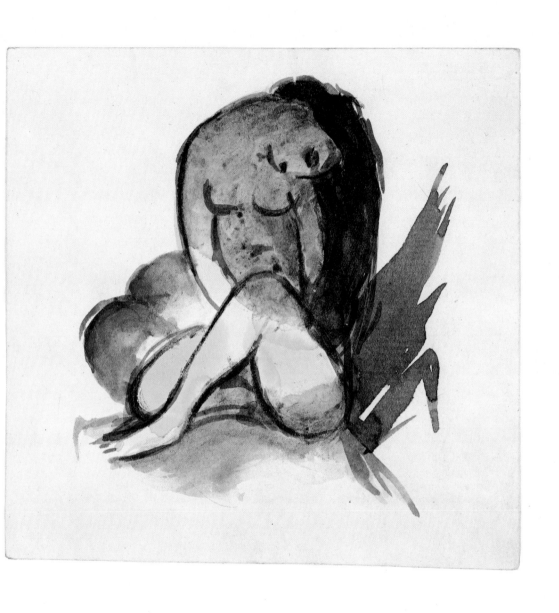

4

Two Blue Horses

Zwei Blaue Pferde

India ink and watercolor

Letter, January 26 (?), 1913

5

Dancer from the Court of King Jussuf

Tänzerin vom Hofe des Königs Jussuf

India ink and watercolor

Letter, January 26 (?), 1913

FRANZ MARC

SINDELSDORF BEI PENZBERG, DEN.................
OBER-BAYERN.

FE 396

Vielen Dank, Lieber, für die Grüße in Küsse, die Bi... und beiden Sendungen aus dem freuend, vor allem Dank für die wunderschönen Lieder. Wir werden ... in dankbarer ... (als ... Gäste) ... ihre Jahrsendung ... ; ... wird ... lieben gedenken, in die ... ihr Liebling ... hat.

Mittwoch Mittag kommen wir nach München, ... wollen Sie uns in ... Residenz ... geschickt etwas für die Nacht von Mittwoch auf Donnerstag bestellen?

Auf gutes Wiedersehen mit freund-
schaft u. Küssen mit vielen
dein ... Kaiser und seine Marcia

Grüße
14.4.?/5

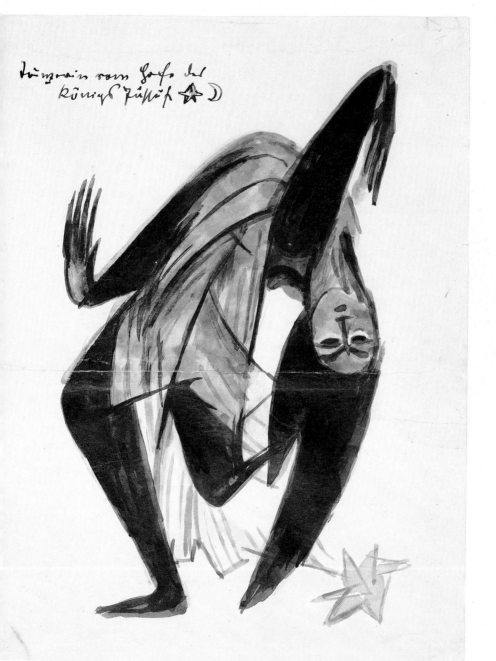

6

The Three Panthers of King Jussuf
Die drei Panther des Königs Jussuf
India ink, watercolor, and gouache
Postcard, February 6, 1913

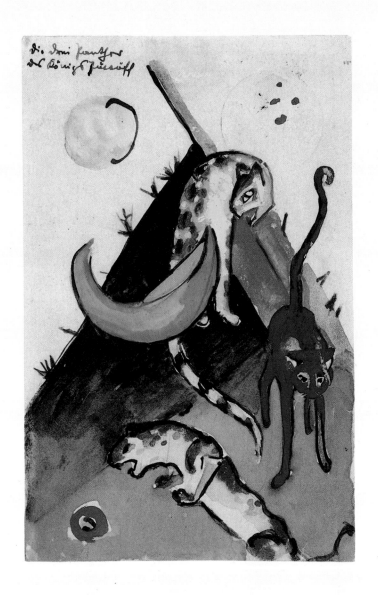

7

The Watering Hole on the Ruby Mountain
Die Tränke am Rubinberge
India ink, watercolor, and gouache
Postcard, February 15, 1913

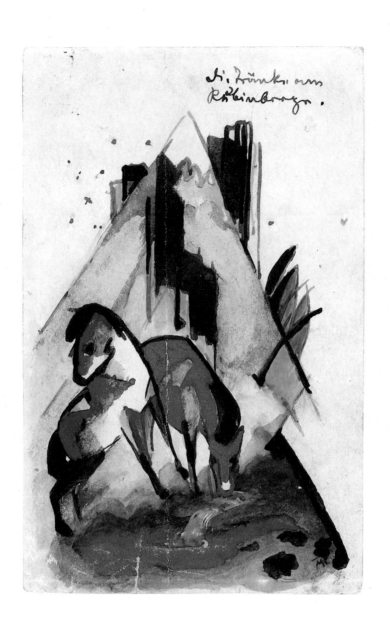

8

From Prince Jussuf's Hunting Grounds
Aus den Jagdgefilden des Prinzen Jussuf
India ink, watercolor, and gouache
Postcard, February 23, 1913

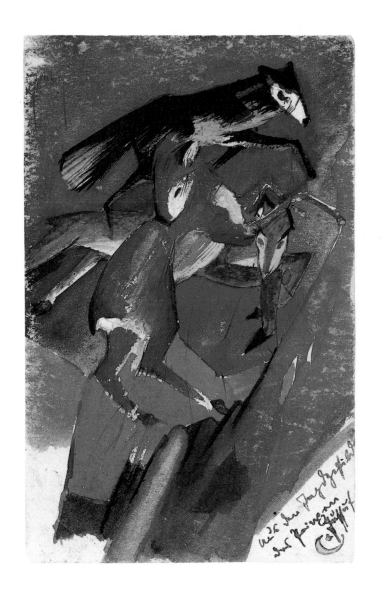

9
Prince Jussuf's Lemon Horse and Fiery Ox
Zitronenpferd und Feuerochse des Prinzen Jussuf
India ink, watercolor, and gouache
Postcard, March 9, 1913

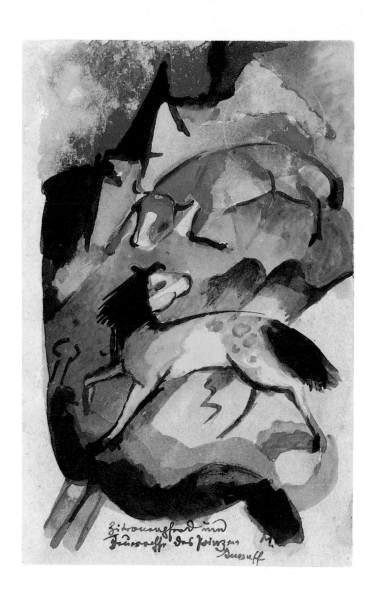

10
King Abigail's Toy Horse
Das Spielpferd des Königs Abigail
India ink, watercolor, and gouache
Postcard, March 14, 1913

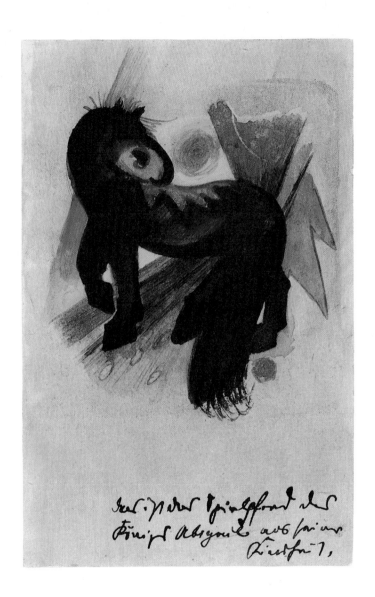

der neue Spielgefährt des
Königs Abgout aus seiner
Kinderzeit,

11

The Brood Mare of the Blue Horses
Die Mutterstute der blauen Pferde
India ink and gouache
Postcard, March 20, 1913

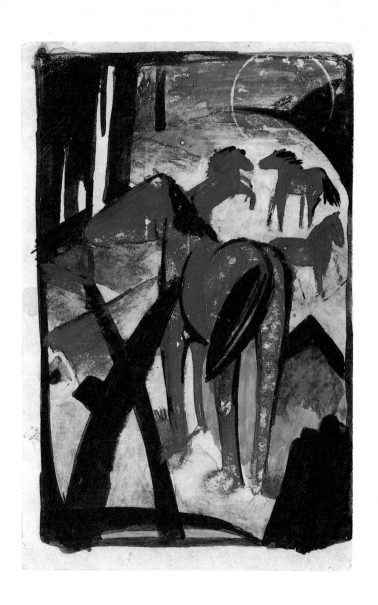

12
The Little Sacred Calf
Das heilige Kälbchen
Gouache and india ink
Postcard, early April 1913

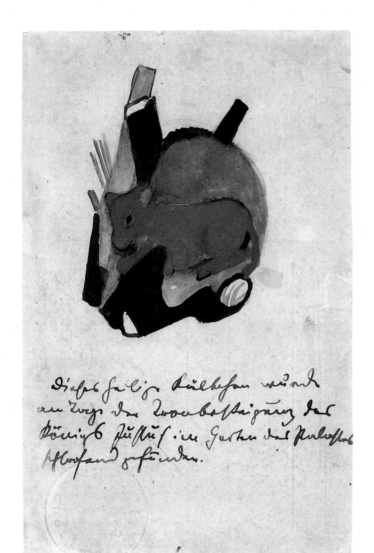

Dieses heilige Rüebchen wurde
am Tage der Wiederbesteigung des
königl. Thrones im Garten der Klosters
Klosterland gefunden.

13

The War Horse of Prince Jussuf
Das Schlachtpferd des Prinzen Jussuf
Watercolor and gouache
Postcard, April 7, 1913

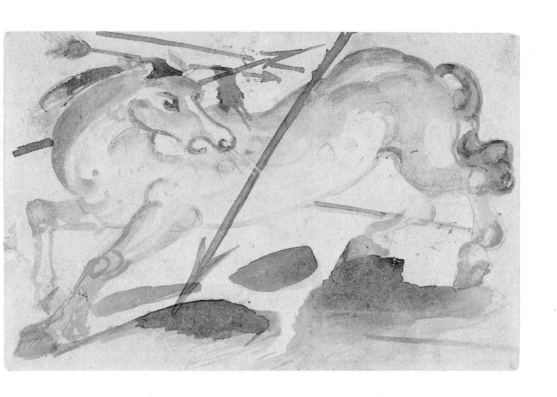

14
Monkeys
Affen
India ink, watercolor, and gouache
Postcard, April 13, 1913

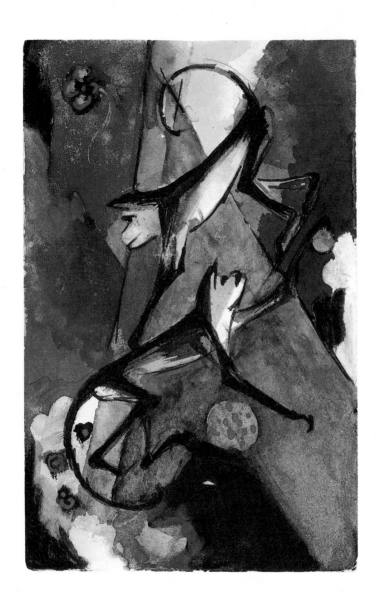

15

Three Animals on the Blue Mountain

Drei Tiere am blauen Berg

Watercolor, gouache, india ink,
and pasted silver paper

Postcard, April 27, 1913

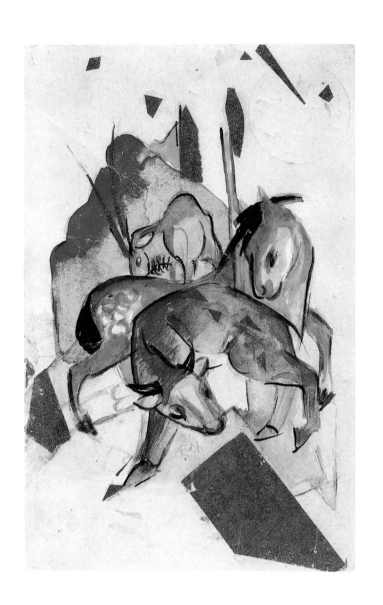

16
Fox and Gazelle
Fuchs und Gazelle
Pen and india ink, and watercolor
Postcard, April 29, 1913

17
From King Jussuf's Nights
Aus König Jussufs Nächten
Watercolor, gouache, and pasted silver paper
Postcard, May 1 (?), 1913

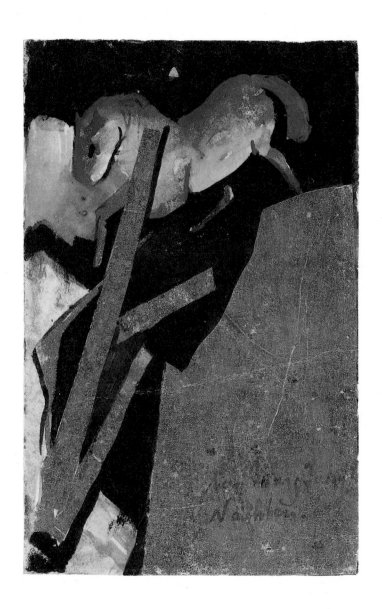

18
Image from Jussuf's Times of Peace
Bild aus Jussuf's Friedenszeiten
Watercolor, gouache, india ink and
pasted silver paper, painted and varnished
Postcard, May 21, 1913

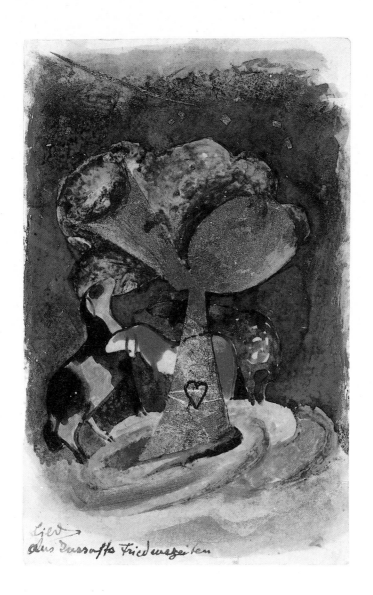

Lied
aus Passaths Friedwegzeiten

19
Black Horse
Schwarzes Pferd
Watercolor and pasted gold paper, varnished
Postcard, May 27, 1913

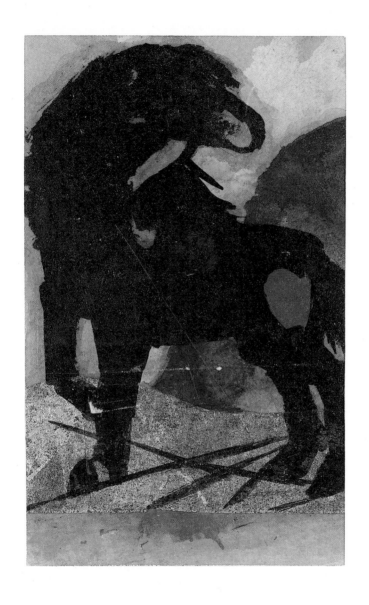

20
Bluish Mythical Creature
Bläuliches Fabeltier
Gouache and india ink
Postcard, July 18, 1913

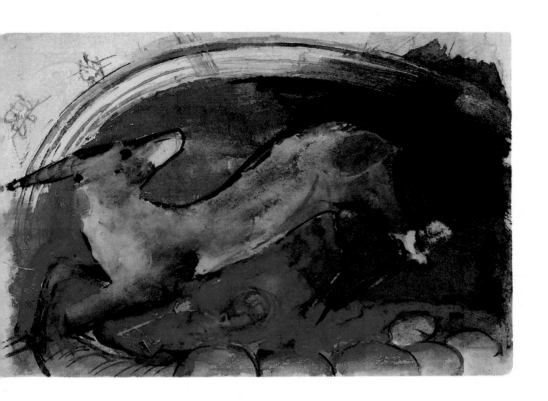

21
Amerindian Horses
Indianerpferde
India ink, watercolor, and gouache
Postcard, September 9, 1913

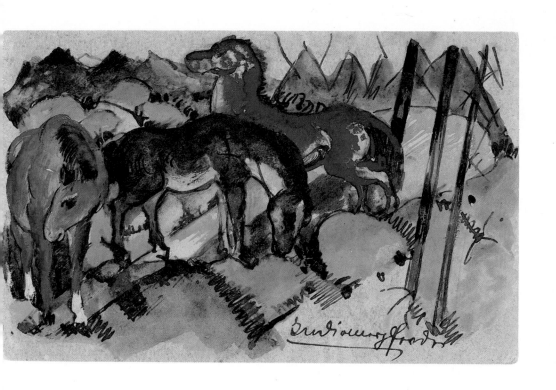

22

The Dream Rock

Der Traumfelsen

Watercolor, gouache, and india ink
Postcard, September 21, 1913

23
Elephant
Elephant
Watercolor, gouache, and india ink
Postcard, October 14, 1913

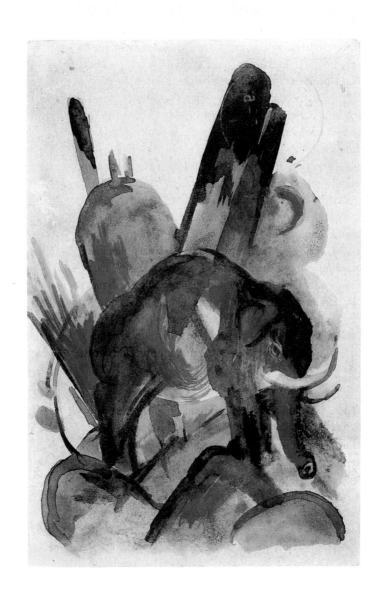

24
From the Ancient Royal City of Thebes
Aus der alten Königstadt Theben
Watercolor and gouache
Postcard, October 29, 1913

25
Ibex
Steinbock
India ink and watercolor
Postcard, December 12, 1913

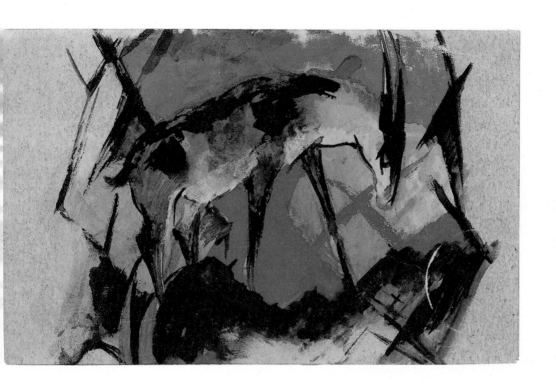

26
Horse
Pferd
Watercolor, gouache, and india ink
Postcard, December 30, 1913

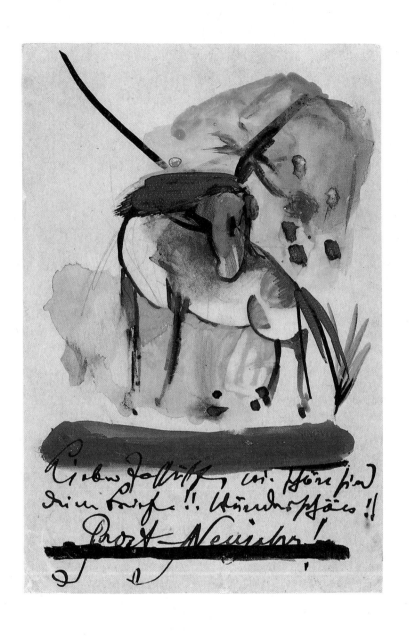

27

Prince Jussuf's Four Attendant Dogs

Die vier Begleithunde des Prinzen Jussuf

Watercolor, gouache, and pencil

Postcard, March 28, 1914

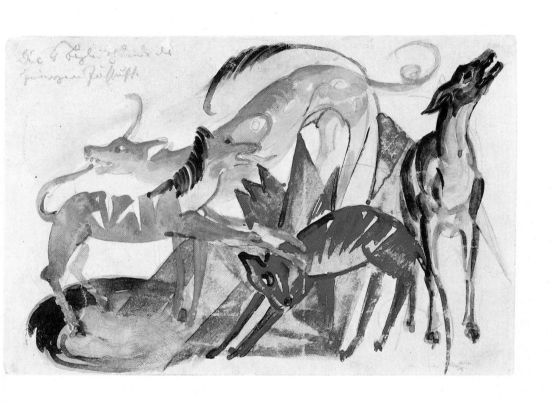

28
Ried Castle
Schloss Ried
Watercolor
Card, April (?) 1914

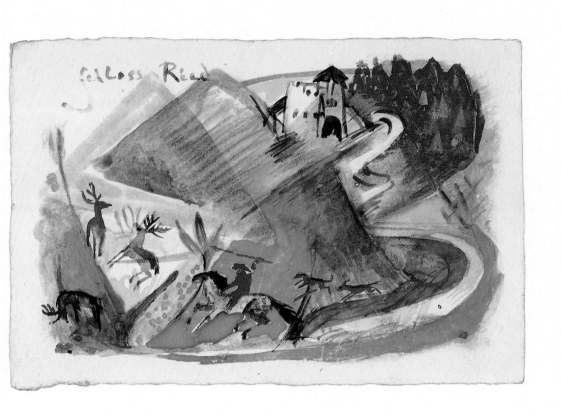

List of Plates

Measurements are given in inches and millimeters,
height before width.
As the postcards from Marc have been reinforced at the corners
for conservation reasons, the text on the verso at these points
is sometimes obscured in the photographs.

Recto of letter (plate 1)

Plate 1

The Blue Rider with His Horse
(Der Blaue Reiter mit seinem Pferd), 1912

India ink and writing ink
6 1/16 x 4 1/2" (154 x 114 mm)

Letter from Munich, December 8 (?), 1912, to Lasker-Schüler in Berlin

Recto: "The Blue Rider presents his Blue Horse to Your Highness. Greetings from my spouse. Yours, Fz. M. Berlin W2, behind the Catholic church, c/o Dr. Franck."

Bayerische Staatsgemäldesammlungen, Munich.
Sofie and Emanuel Fohn Donation. 13 556

Verso of postcard (plate 2)

Plate 2

The Tower of Blue Horses
(Der Turm der Blauen Pferde), 1912 or 1913

India ink and gouache
5 5/8 x 3 11/16" (143 x 94 mm)

Postcard from Berlin, late December 1912 or early January 1913, to Lasker-Schüler in Berlin

Recto: "The Tower of Blue Horses."
Verso: "Many, many thanks, my dear friend, for the beautiful books and the inscription and the message to my Mareia. Shall we meet Saturday? Afraid we can't in the evening, but whenever and as often as you like in the daytime. Write or telephone us, will you? Happy New Year and greetings to little Paul [Lasker-Schüler's son]. Yours, Fz. M. & M."

Bayerische Staatsgemäldesammlungen, Munich.
Sofie and Emanuel Fohn Donation. 13 550

Plate 3

Yellow Seated Female Nude
(Sitzender gelber Frauenakt), 1913

India ink and watercolor
5 5/8 x 5 3/4" (143 x 147mm)

Letter from Sindelsdorf, January 22, 1913, to Lasker-Schüler in Munich

Verso: "22.1.1913. [On a sheet pasted to the verso:] Dear Prince, your Dresden letter came back today, marked undeliverable; I am enclosing it now. Is Kneipp's *Wasserkur* yours or someone else's in Sindelsdorf? Write me, and I'll send it to you. I'm glad the Gastein water is doing you good. All our good wishes go with you at all times. Cordially from us both, The Blue Rider. Do send us Werfel's book [probably *Der Weltfreund*], won't you?"

Staatliche Museen, Sammlung der Zeichnungen, Berlin, GDR. M 23, F II 87

Verso of postcard (plate 3)

Plate 4

Two Blue Horses
(*Zwei blaue Pferde*), 1913

India ink and watercolor
Sheet 8⅞ x 6⅞" (224 x 176 mm), image 3¾ x 2⅛"
(95 x 55 mm)
Letter from Sindelsdorf, January 26 (?), 1913, to Lasker-Schüler in Munich

Recto: [printed letterhead]
Verso: [letter, plate 5]

Staatliche Museen, Sammlung der Zeichnungen,
Berlin, GDR. M 28, F II 878

Verso of letter (plate 4)

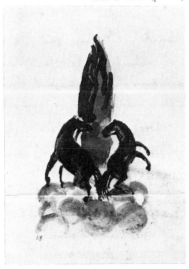
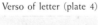

Plate 5

Dancer from the Court of King Jussuf
(*Tänzerin vom Hofe des Königs Jussuf*), 1913

India ink and watercolor
8¹³⁄₁₆ x 6¹⁵⁄₁₆" (224 x 176 mm)
Letter from Sindelsdorf, January 26 (?), 1913, to Lasker-Schüler in Munich (continuation of plate 4)

Recto: "Dancer from the Court of King Jussuf."
Facing verso page on left: "Many thanks, dear, for the greetings and kisses you send to us and to our friend's [painter Heinrich Campendonk's] bramble lips; thank you above all for the wonderful songs. We shall make a thank-offering today (like real gods) in celebration of your recovery, and drink a wine that is the color of the hair of your favorite minister. We arrive in Munich Wednesday around noon [in margin: between 12 and 12.30] – please will you have your boardinghouse reserve us a heated room for Wednesday night? Until we see you, with a handclasp and kisses from us all. The Blue Rider and Frau Mareia."

Staatliche Museen, Sammlung der Zeichnungen,
Berlin, GDR. M 28, F II 878

Drawing with letter on facing half-sheet (plate 5)

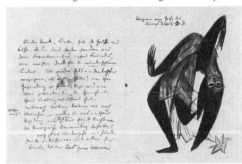

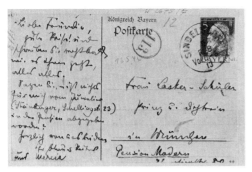

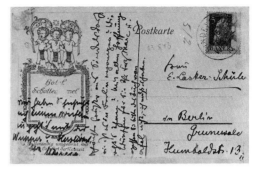

Verso of postcard (plate 6)

Verso of postcard (plate 7)

Plate 6

The Three Panthers of King Jussuf
(*Die drei Panther des Königs Jussuf*), 1913

India ink, watercolor, and gouache
5⁷⁄₁₆ x 3⁹⁄₁₆" (138 x 90 mm)
Postcard from Sindelsdorf, February 6, 1913, to Lasker-Schüler in Munich

Recto: "The Three Panthers of King Jussuf."
Verso: "My dear friend, have a good trip! And write us really soon, how you are, everything. Tell me – has anything been delivered to the boardinghouse for me from the jeweler's (Steinburger, Schellingstrasse 23)? Cordially, from both of us, your Blue Rider and Mareia."

Bayerische Staatsgemäldesammlungen, Munich.
Sofie and Emanuel Fohn Donation. 13 546

Plate 7

The Watering Hole on the Ruby Mountain
(*Die Tränke am Rubinberge*), 1913

India ink, watercolor, and gouache
5¹¹⁄₁₆ x 3¹¹⁄₁₆" (145 x 93 mm)
Postcard from Sindelsdorf, February 15, 1913, to Lasker-Schüler in Berlin

Recto: "The Watering Hole on the Ruby Mountain."
Verso: "Best wishes from Sindelsdorf; how did it go in Berlin? How are you? With all our hopes and wishes for you. Yours, Frz. Marc & please don't forget the book by Franz

Werfel – I must have it. [In Maria Marc's hand:] We're longing for a line or two. How's *Die Wupper* [play by Lasker-Schüler] going? Yours affectionately, Mareia."

Bayerische Staatsgemäldesammlungen, Munich.
Sofie and Emanuel Fohn Donation. 13 543

Verso of postcard (plate 8)

Plate 8

From Prince Jussuf's Hunting Grounds
(*Aus den Jagdgefilden des Prinzen Jussuf*), 1913

India ink, watercolor, and gouache
5¹¹⁄₁₆ x 3¹¹⁄₁₆" (145 x 93 mm)
Postcard from Sindelsdorf, February 23, 1913, to Lasker-Schüler in Berlin

Recto: "From Prince Jussuf's Hunting Grounds."
Verso: "Dear friend, no news is good news. – We hope so anyway, and send you a thousand greetings. We are fine, painting, eating, or sleeping all day long, the pure

beasts. Yours, Franz M. & Marei. P.S. Why don't you send me the Werfel book? Please!"

Bayerische Staatsgemäldesammlungen, Munich. Sofie and Emanuel Fohn Donation. 13 547

Verso of postcard (plate 10)

Plate 9

Prince Jussuf's Lemon Horse and Fiery Ox

(*Zitronenpferd und Feuerochse des Prinzen Jussuf*), 1913

India ink, watercolor, and gouache
5 ½ x 3 ⁹⁄₁₆″ (140 x 91 mm)

Postcard from Sindelsdorf, March 9, 1913, to Lasker-Schüler in Berlin

Recto: "Prince Jussuf's Lemon Horse and Fiery Ox. M."

Verso: "Dear Good Prince, it was kind of you to write to our mother, it gave her great pleasure. So many stars shine into our bedroom that we have no need to light up starry nightlights, so we are all the happier! We look forward to the March letters [the 'Briefe an den blauen Reiter Franz Marc,' which Lasker-Schüler was hoping to publish in the periodical *März* (March)]; we have an order in for them already. A kiss from your blue children."

Bayerische Staatsgemäldesammlungen, Munich. Sofie and Emanuel Fohn Donation. 13 544

Plate 10

King Abigail's Toy Horse

(*Das Spielpferd des Königs Abigail*), 1913

India ink, watercolor, and gouache
5 ¹₂ x 3 ⁹⁄₁₆″ (139 x 90 mm)

Postcard from Sindelsdorf, March 14, 1913, to Lasker-Schüler in Hagen

Recto: "This was King Abigail's toy horse in his childhood."

Verso: "Dear Prince. The dragonfly [the toy horse] is 15 years old; it cost 50 marks at Tietz's then; the star on the back is sealing wax. It can't compete with the beautiful glass penholder or the jewelry; it never tried to. After 15 years in Mareia's service it fluttered off into the Grunewald pine woods, and that's where you caught it. Regards to big Paul. The thing I like best about E. A. [Berlin painter Egon Adler] is his beautiful walking stick, baton, scepter. Affec. Mareia & I, both yours."

Bayerische Staatsgemäldesammlungen, Munich. Sofie and Emanuel Fohn Donation. 13 536

Plate 11

The Brood Mare of the Blue Horses

(*Die Mutterstute der blauen Pferde*), 1913

India ink and gouache
5 ½ x 3 ⁹⁄₁₆″ (140 x 90 mm)

Postcard from Sindelsdorf, March 20, 1913, to Lasker-Schüler in Hagen

Verso: "Dear Prince, this is the brood mare of the blue horses, from the Prince of Thebes's

Verso of postcard (plate 9)

95

stud farm. We're going to Merano for a few days to see our parents. Father is very ill in a sanitorium there (Franck, Villa Maja, Merano). Affectionately from us both [illegible] Franz. Regards to Paul."

Bayerische Staatsgemäldesammlungen, Munich. Sofie and Emanuel Fohn Donation. 13 549

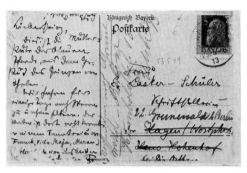

Verso of postcard (plate 11)

Plate 12

The Little Sacred Calf
(*Das heilige Kälbchen*), 1913
Gouache and india ink
5 ½ x 3 9⁄16″ (140 x 90 mm)
Postcard from Sindelsdorf, early April 1913, to Lasker-Schüler in Munich

Recto: "This little sacred calf was found sleeping in the palace gardens on the day King Jussuf ascended the throne."
Verso: "It was kind of you to come to the station. The hearts tasted good and our Mario [the Marcs' dog] was royally delighted and sends many thanks. We hope you enjoy Prague - Your Frz. & Mareia = loyal."

Bayerische Staatsgemäldesammlungen, Munich. Sofie and Emanuel Fohn Donation. 13 535

Verso of postcard (plate 12)

Plate 13

The War Horse of Prince Jussuf
(*Das Schlachtpferd des Prinzen Jussuf*), 1913
Watercolor and gouache
5 9⁄16″ x 3 9⁄16″ (141 x 91 mm)
Postcard from Sindelsdorf, April 7, 1913, to Lasker-Schüler in Prague

Recto: "Dearest, this is the war horse of Prince Jussuf - fearful! Greetings, dear sister, Franz & Mareia."

Bayerische Staatsgemäldesammlungen, Munich. Sofie and Emanuel Fohn Donation. 13 552

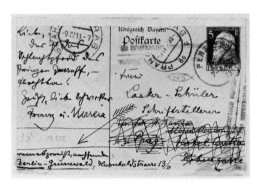

Verso of postcard (plate 13)

Plate 14

Monkeys
(*Affen*), 1913

India ink, watercolor, and gouache
5⁹/₁₆ x 3⁹/₁₆" (141 x 91 mm)

Postcard from Sindelsdorf, April 13, 1913, to Lasker-Schüler in Berlin

Verso: "Prince, don't get angry on my account! I'm used to human stupidity. If *März* [see text, plate 9] will take it with someone else's name on it, let them have it; *we* know whom it was written for, that's quite enough. People don't deserve us, and that's why we're here at Sindelsdorf. *Pan* doesn't come out every week any more. It's still good and beautiful – however you do it. Affec. yours, Frz. & Mareia. [P.S. above:] Was the *War Horse* sent on to you from Prague (Hotel C)? I did put the Berlin forwarding address on the card."

Bayerische Staatsgemäldesammlungen, Munich. Sofie and Emanuel Fohn Donation. 13 545

Verso of postcard (plate 15)

Plate 15

Three Animals on the Blue Mountain
(*Drei Tiere am blauen Berg*), 1913

Watercolor, gouache, india ink, and pasted silver paper
5⁹/₁₆ x 3⁹/₁₆" (141 x 91 mm)

Postcard from Sindelsdorf, April 27, 1913, to Lasker-Schüler in Berlin

Verso:"Dear, how are you? Better? You must get better. Write us! Tender kiss, Franz & Mareia."

Bayerische Staatsgemäldesammlungen, Munich. Sofie and Emanuel Fohn Donation. 13 554

Verso of postcard (plate 14)

Plate 16

Fox and Gazelle
(*Fuchs und Gazelle*), 1913

Pen and india ink, and watercolor
5⁵/₈ x 3⁹/₁₆" (142 x 91 mm), image mounted on the card
3⅛ x 3¹/₁₆" (80 x 78 mm)

Postcard from Sindelsdorf, April 29, 1913, to Lasker-Schüler in Berlin

Verso of postcard (plate 16)

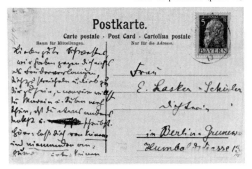

Recto: [continuation of text on verso]
Verso: "Dear, good Sister, we have nothing against you, only a brotherly desire to stroke you and be kind to you, and why must you hurt your Mareia and Reuben by thinking and writing otherwise? Listen: let nobody, in any [continued on recto] circumstances whatsoever, sponge off you. The little treasure [money collected on Lasker-Schüler's behalf by friends in Vienna and Munich] belongs to you and to your little Paul, and not to anyone else. We look forward to the letters, that's great! How are you? All the best from your Franz & Mareia."

Bayerische Staatsgemäldesammlungen, Munich. Sofie and Emanuel Fohn Donation. 13 542

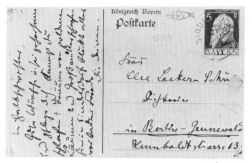

Verso of postcard (plate 18)

Plate 18

Image from Jussuf's Times of Peace
(*Bild aus Jussuf's Friedenszeiten*), 1913

Watercolor, gouache, india ink, and pasted silver paper, painted and varnished
5⁹/₁₆ x 3⁹/₁₆" (141 x 90 mm)
Postcard from Sindelsdorf, May 21, 1913, to Lasker-Schüler in Berlin

Recto: "Image from Jussuf's Times of Peace."
Verso: "Dear Half Sister, All good wishes, and do as you are told and take care of yourself. Can you sleep? Dream of golden trees and grandmother sheep. Here at Sindelsdorf, such is the peace that we all bleat. Yours both."

Bayerische Staatsgemäldesammlungen, Munich. Sofie and Emanuel Fohn Donation. 13 551

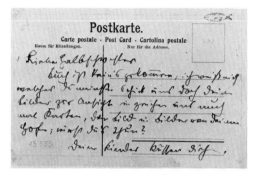

Verso of postcard (plate 17)

Plate 17

From King Jussuf's Nights
(*Aus König Jussufs Nächten*), 1913

Watercolor, gouache, and pasted silver paper
5⁹/₁₆ x 3⁹/₁₆" (141 x 91 mm)
Postcard from Sindelsdorf, May 1 (?), 1913, to Lasker-Schüler in Berlin

Recto: "From King Jussuf's Nights."
Verso: "Dear Half Sister, no book has come. I don't know which one you mean. Do send us your pictures to look at, and draw postcards for us too, pictures of yourself and your Court; will you do it? Your children kiss you."

Bayerische Staatsgemäldesammlungen, Munich. Sofie and Emanuel Fohn Donation. 13 553

Plate 19

Black Horse
(*Schwarzes Pferd*), 1913

Watercolor and pasted gold paper, varnished
5½ x 3⁹/₁₆" (140 x 90 mm)
Postcard from Sindelsdorf, May 27, 1913, to Lasker-Schüler in Berlin

Verso: "Dear Sister, if your present milieu annoys you too much, mount this dark steed and hasten hither. We received your *Gesichte* [Visions, a volume of essays and stories] some time ago – we so love dipping into it. You are so much there in it. Thank you also for the inscription; I have written you a card

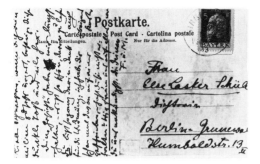

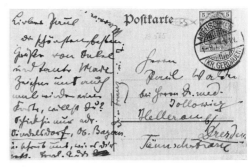

Verso of postcard (plate 19)　　　　　　　Verso of postcard (plate 21)

already – didn't you get it? We look forward
to all you announce to us. Your F. & M."

Staatliche Museen, Sammlung der Zeichnungen,
Berlin, GDR. M 4, F II 878

Plate 21

Amerindian Horses
(*Indianerpferde*), 1913

India ink, watercolor, and gouache
5 5/8 x 3 1/2" (142 x 89 mm)

Postcard from Abelischken, Gerdauen district, East
Prussia, September 9, 1913, to Paul Walden, Lasker-
Schüler's son, at Hellerau, near Dresden

Recto: "Amerindian horses."
Verso: "Dear Paul, all very best wishes from
Uncle and Aunt Marc. Draw us a card again,
will you? Just send it to Sindelsdorf, Upper
Bavaria, and write us how you are. Best
wishes, your Franz and A[unt]. Mareia."

Bayerische Staatsgemäldesammlungen, Munich.
Sofie and Emanuel Fohn Donation. 13 555

Plate 20

Bluish Mythical Creature
(*Bläuliches Fabeltier*), 1913

Gouache and india ink
3 9/16 x 5 1/2" (91 x 139 mm)

Postcard from Sindelsdorf, July 18, 1913, to Lasker-
Schüler in Berlin

Verso: "Greetings from your Sindelsdorf
Brothers! [Centrally placed, a green wax seal
with mark of a horse; above and to its right,
a Japanese stamp; beneath and between the
two, a red sun with rays. Below, in Maria
Marc's hand:] Dear Sister, how are you? We
hear nothing. When are you coming? Mareia."

Bayerische Staatsgemäldesammlungen, Munich.
Sofie and Emanuel Fohn Donation. 13 541

Verso of postcard (plate 20)

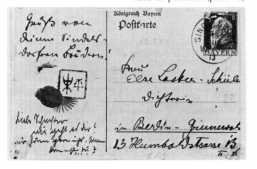

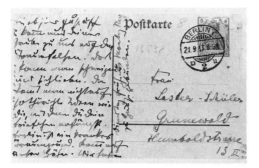

Verso of postcard (plate 22)

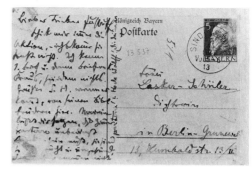

Verso of postcard (plate 23)

Plate 22

The Dream Rock
(*Der Traumfelsen*), 1913

Watercolor, gouache, and india ink
5 5/8 x 3 1/2" (142 x 89 mm)
Postcard from Berlin, September 21, 1913, to Lasker-Schüler in Berlin

Recto: "The Dream Rock."
Verso: "Dearest Jussuf, rise up from your grave to our Dream Rock. There it is possible to say nothing and love one another. There people do not have foolish ideas such as the one with which you begin your letter. Berlin is a sick background for a dream. Rise up to our level. We leave early Tuesday. Tied to the house Monday. Keep on loving us. Yours."

Bayerische Staatsgemäldesammlungen, Munich.
Sofie and Emanuel Fohn Donation. 13 538

Plate 23

Elephant
(*Elephant*), 1913

Watercolor, gouache, and india ink
5 1/2 x 3 9/16" (139 x 91 mm)
Postcard from Sindelsdorf, October 14, 1913, to Lasker-Schüler in Berlin

Verso: "Dear, dear Jussuf, keep sending me *Die Aktion*, otherwise I can't get it! I know 1st letter and then K. Kraus letter [letters 1 and 6 of the 'Briefe an den Blauen Reiter Franz Marc'], nothing more. Greet H. M., when he comes, on behalf of his biblical brothers. Mareia sends word that ground-

floor room absolutely must be dry; they are so damp and unhealthy [illegible] why not ground floor!? Hurrah for Wolff![publisher Kurt Wolff, who had just accepted Lasker-Schüler's new book, *Der Prinz von Theben*] Yours."

Bayerische Staatsgemäldesammlungen, Munich.
Sofie and Emanuel Fohn Donation. 13 537

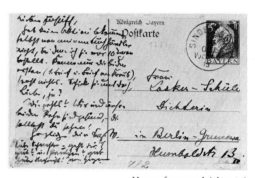

Verso of postcard (plate 24)

Plate 24

From the Ancient Royal City of Thebes
(*Aus der alten Königstadt Theben*), 1913

Watercolor and gouache
3 9/16 x 5 1/2" (91 x 140 mm)
Postcard from Sindelsdorf, October 29, 1913, to Lasker-Schüler in Berlin

Recto: "From the ancient royal city of Thebes."
Verso: "Dear Jussuf, I haven't gotten an *Aktion*, even from my bookseller, from whom I ordered it 10 days ago. I know only the first two [letter 1 and letter to Kraus], nothing

more. Please do send them to us, dear, will you? How are you? We and our two deer are well – you ought to see them! Affectionately, your Frz. M. [In Maria Marc's hand:] Dear Sister – are you well? & little Paul? News please! Your devoted Mareia."

Bayerische Staatsgemäldesammlungen, Munich. Sofie and Emanuel Fohn Donation. 13 540

Verso of postcard (plate 26)

Plate 25

Ibex
(*Steinbock*), 1913

India ink and watercolor
3 1/2 x 5 9/16″ (89 x 141 mm)
Postcard from Berlin, December 12, 1913, to Lasker-Schüler in Berlin

Verso: "Dearest Jussuf, our good father has ended his sufferings; we bury him tomorrow. It is all so sad. We want to visit you Monday afternoon; is that all right? Your Frz. & M. W2, behind the Catholic Church."

Staatliche Museen, Sammlung der Zeichnungen, Berlin, GDR. M 25, F II 878

Plate 26

Horse
(*Pferd*), 1913

Watercolor, gouache, and india ink
5 3/4 x 3 7/8″ (146 x 99 mm)
Postcard from Sindelsdorf, December 30, 1913, to Lasker-Schüler in Berlin

Recto: "Dear Jussuf, how lovely your letters are! Wondrous! Happy New Year!"

Bayerische Staatsgemäldesammlungen, Munich. Sofie and Emanuel Fohn Donation. 13 539

Plate 27

Prince Jussuf's Four Attendant Dogs
(*Die vier Begleithunde des Prinzen Jussuf*), 1914

Watercolor, gouache, and pencil
3 9/16 x 5 1/2″ (90 x 140 mm)
Postcard from Sindelsdorf, March 28, 1914, to Lasker-Schüler in Berlin

Recto: "Prince Jussuf's Four Attendant Dogs." Verso: "Dear Jussuf, your letter from Frank-

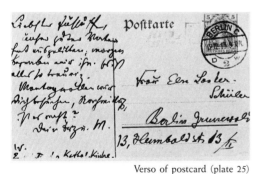

Verso of postcard (plate 25)

Verso of postcard (plate 27)

furt had the right address on it. I sent it on right away. I had written a few days earlier. How was it in Frankfurt? If only I could give you 4 such dogs, to fend off all that has no business harassing you. Greetings from us both. Your F./M."

Bayerische Staatsgemäldesammlungen, Munich. Sofie and Emanuel Fohn Donation. 13548

Verso of card (plate 28)

Plate 28

Ried Castle
(*Schloss Ried*), 1914

Watercolor
4½ x 7" (115 x 177mm)
Card from Ried, near Benediktbeuern, April (?) 1914, to Lasker-Schüler in Berlin

Recto: "Ried Castle."
Verso: "Dear Jussuf, I'm sending this for Paul; I've drawn it for him, so that he can see what our castle is like! Hurrah for Jussuf! Yours both." [Written above a printed announcement of the engagement of Berta Hugger to Emil Büchler]

Staatliche Museen, Sammlung der Zeichnungen, Berlin, GDR. M24, F II 878

Bibliography

Almanach "Der Blaue Reiter." Ed. Wassily
 Kandinsky and Franz Marc. Documentary
 edition by Klaus Lankheit, 5th ed. Munich,
 1984. English translation: *The Blaue Reiter
 Almanac.* London and New York, 1974.

Bänsch, Dieter. *Else Lasker-Schüler: Zur Kritik eines
 etablierten Bildes.* Stuttgart, 1971.

Bauschinger, Sigrid. *Else Lasker-Schüler: Ihr Werk
 und ihre Zeit.* Poesie und Wissenschaft,
 vol. 8. Heidelberg, 1980.

Delaunay und Deutschland. Exhibition catalogue.
 Ed. Peter-Klaus Schuster. Munich, Staats-
 galerie moderner Kunst. Cologne, 1985.

Expressionisten. Exhibition catalogue. Staatliche
 Museen zu Berlin, Nationalgalerie and
 Kupferstichkabinett. Berlin, GDR, 1986.

Fohn: *Schenkung Sofie und Emanuel Fohn.* Exhibi-
 tion catalogue. Ed. Wolf-Dieter Dube, with
 an essay by Kurt Martin. Munich,
 Bayerische Staatsgemäldesammlungen.
 Munich, 1965.

Guder, G. "The Meaning of Colour in Else
 Lasker-Schüler's Poetry." *German Life and
 Letters,* vol. 14 (1960–61), p. 175 ff.

Hessing, Jakob. *Else Lasker-Schüler: Ein Leben
 zwischen Bohème und Exil.* Munich, 1987.

Hüneke, Andreas. *Der Blaue Reiter: Dokumente
 einer geistigen Bewegung.* Leipzig, 1986.

Kandinsky, Wassily, and Franz Marc. *Briefwechsel.*
 Ed. Klaus Lankheit. Munich, 1983.

Klüsener, Erika. *Else Lasker-Schüler in Selbstzeug-
 nissen und Bilddokumenten.* Reinbek, 1980.

Lankheit, Klaus. *Franz Marc im Urteil seiner Zeit.*
 Cologne, 1960.

——. *Franz Marc: Katalog der Werke.* Cologne,
 1970.

——. *Franz Marc: Sein Leben und seine Kunst.*
 Cologne, 1976.

——. *Franz Marc und Kochel: Festvortrag anlässlich
 der Eröffnung des Franz Marc Museums,
 Kochel am See, 4. Juli 1986.* Munich, 1986.

——. *Führer durch das Franz Marc Museum, Kochel
 am See.* 2nd ed. Munich, 1987.

Lasker-Schüler, Else. *Gesammelte Werke.* Ed. Fried-
 helm Kemp and Werner Kraft. 3 vols.
 Munich, 1959–62. Reprint (8 vols.). Munich,
 1986.

——. *Der Malik: Eine Kaisergeschichte mit Bildern
 und Zeichnungen von Else Lasker-Schüler.*
 Epilogue by Erich Fried. Kiel, 1983.

——. "Briefe an den blauen Reiter Franz Marc."
 Reprinted in Schuster, 1987.

——. *Briefe von Else Lasker-Schüler.* Ed. Margarete
 Kupper. 2 vols. Munich, 1969.

Macke, August, and Franz Marc. *Briefwechsel.* Ed.
 Wolfgang Macke. Cologne, 1964.

Marc, Franz. *Briefe aus dem Feld.* Berlin, 1941.

——. *Schriften.* Ed. Klaus Lankheit. Cologne, 1978.

——. *Botschaften an den Prinzen Jussuf.* Foreword
 by Maria Marc and essay "Über das
 Poetische in der Kunst Franz Marcs" by
 Georg Schmidt. Munich, 1954.

——. *Franz Marc, 1880–1916.* Exhibition cata-
 logue, Munich, Städtische Galerie im
 Lenbachhaus. Munich, 1980.

Pfäfflin, Friedrich, ed. *Nachrichten aus dem Kösel-
 Verlag: Sonderheft für Else Lasker-Schüler.*
 Munich, 1965.

Schuster, Peter-Klaus, ed. *Franz Marc, Else Lasker-
 Schüler: "Der Blaue Reiter präsentiert Eurer
 Hoheit sein Blaues Pferd" – Karten und Briefe.*
 Munich, 1987.

Webb, Karl E. "Else Lasker-Schüler and Franz
 Marc: A Comparison." *Orbis Litterarum,* no.
 33 (1978), p. 280 ff.